8/05

A Kid's Guide to Drawing the Countries of the World™

How to Draw
Ireland's
Sights and Symbols

Cindy Fazzi

The Rosen Publishing Group's
PowerKids Press™
New York

To my editor and friend Rachel O'Connor,
for her quintessential Irish warmth and vivacity

Published in 2005 by The Rosen Publishing Group, Inc.
29 East 21st Street, New York, NY 10010

First Edition

Editor: Rachel O'Connor
Book Design: Kim Sonsky
Layout Design: Nick Sciacca

Illustration Credits: Cover and inside by Holly Cefrey.

Photo Credits: Cover and title page (hand) Arlan Dean; cover (harp), p. 18 (bottom) © Martin Moos/Lonely Planet Images; pp. 5, 30 (right), 40 (bottom) © Michael St. Maur Sheil/Corbis; p. 9 © Richard Cummins/Corbis; p. 10 © Jason Hawkes/Corbis; p. 12 © Hulton-Deutsch Collection/Corbis; p. 13 Brian P. Burns Irish Art Collection; p. 18 (top) © Charles W. Campbell/Corbis; p. 20 © Michael S. Yamashita/Corbis; p. 22 © Steve Vidler/SuperStock, Inc.; p. 24 © Tim Thompson/Corbis; p. 26 © Ted Spiegel/Corbis; p. 28 © Eoin Clark/Lonely Planet Images; p. 30 (left) © Michael Rutherford/SuperStock, Inc.; p. 32 (left) © Kindra Clineff/Index Stock Imagery, Inc.; p. 32 (right) © Stapleton Collection/Corbis; p. 34 © Richard Cummins/Lonely Planet Images; p. 36 © Geray Sweeney/Corbis; p. 38 © Felix Zaska/Corbis; p. 40 (top) © Corbis; p. 42 © Carl McColman (www.carl.mccolman.name).

Library of Congress Cataloging-in-Publication Data

Fazzi, Cindy.
How to draw Ireland's sights and symbols / Cindy Fazzi.
 p. cm. — (A kid's guide to drawing the countries of the world)
Includes bibliographical references and index.
Summary: Presents step-by-step directions for drawing the national flag, currency, map, and other symbols.
ISBN 1-4042-2738-5 (lib. bdg.)
1. Ireland—In art—Juvenile literature. 2. Drawing—Technique—Juvenile literature. [1. Ireland—In art.
2. Drawing—Technique.] I. Title. II. Series.
NC825.I75 F39 2005
743'.899415—dc22
 2003016445

Manufactured in the United States of America

CONTENTS

Let's Draw Ireland

The first settlers of Ireland are believed to have come from Great Britain around 6000 B.C. They survived by fishing and hunting. It wasn't until 3000 B.C. that the people in Ireland learned how to plant crops and to raise animals.

Around 500 B.C., a group of people from Europe called the Celts began attacking Ireland. Nobody knows why the Celts came to Ireland, but they succeeded in taking over the country. The Celts divided Ireland into small kingdoms according to their family groups, called *fine*. The kingdoms were called *tuathe*. Celtic control lasted for more than 1,000 years. This is so long that many Celtic customs and traditions are practiced in Ireland even today. For example, the Celts introduced their language, Gaelic, which is still spoken in parts of Ireland.

Around A.D. 795, a group of people from Scandinavia known as the Vikings began attacking Ireland. They fought the Celts for 200 years. In 1014, Brian Boru, high king of Ireland, finally beat the

When Christianity was first brought to Ireland, many monasteries were set up as places of learning and prayer. Shown is the round tower at Glendalough Monastery in County Wicklow. Round towers were built as lookouts for Viking attackers.

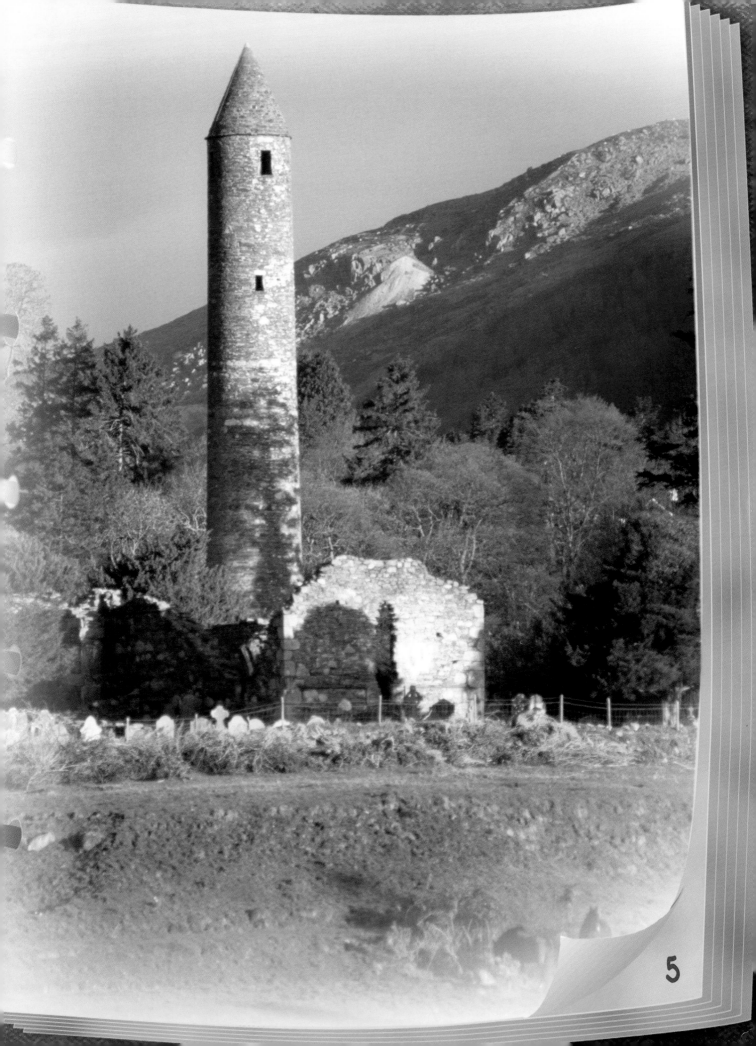

Vikings. In the 1160s, however, England attacked and conquered almost all of Ireland. In 1541, King Henry VIII of England became king of Ireland. English rule in Ireland strengthened throughout the 1700s. English rulers gave away Irish land to English settlers, who were Protestants. Life for the Irish, who were Catholics, got worse because the English would not allow them to buy or inherit land. The Irish rebelled many times, but, in 1801, a law was passed that made Ireland a part of Great Britain.

In 1916 and 1919, different political groups in Ireland announced the country's independence. Both times there was fighting between Irish and British soldiers. In 1921, a treaty between Ireland and Britain was signed, dividing Ireland in two. Twenty-six counties in southern Ireland became the Irish Free State, which enjoyed some independence. The six remaining counties in the north stayed a part of Britain. They are still a part of Britain today. The people in the Irish Free State continued to push for complete independence. They succeeded in 1949.

Today, Ireland is an independent republic with a president as head of the country and a prime

minister as head of the government. Ireland also has a parliament, which makes the laws of the country. It consists of the House of Representatives, known as the Dail Eireann, and the Senate, also called Seanad Eireann.

In this book you will learn more about Ireland and how to draw some of the country's sights and symbols. Directions are under each step. New steps are shown in red. You will need the following supplies to draw Ireland's sights and symbols:

- A sketch pad
- An eraser
- A number 2 pencil
- A pencil sharpener

These are some of the shapes and drawing terms you need to know to draw Ireland's sights and symbols:

— Horizontal line

⌇⌇⌇ Squiggly line

◯ Oval

△ Triangle

▭ Rectangle

| Vertical line

▬ Shading

∿ Wavy line

╱ Slanted line

More About Ireland

Ireland is famous for its natural beauty, such as its magnificent cliffs, beaches, lakes, and green fields. Many tourists visit the Ring of Kerry, a scenic road that follows the coast of the Iveragh Peninsula in the south. The majestic Cliffs of Moher are found in the western part of the island. Visitors also come to see Ireland's many castles, such as Kilkenny Castle in the southeast.

There are almost 4 million people in the Republic of Ireland. Of them, 92 percent are Roman Catholic and 3 percent are Protestant. Dublin is the country's capital. It is also its most-populated city, with more than 952,000 people.

For a long time, Ireland depended on agriculture, especially on growing potatoes, to feed its people. From 1845 to 1848, Ireland's potato crop died because of a plant disease called blight. The lack of potatoes resulted in what was known as the Great Famine. Today farmers in Ireland grow not only potatoes, but also barley, sugar beets, and wheat. They raise poultry, sheep, cattle, and hogs. Fishing is

Located on Ireland's west coast on the Atlantic Ocean, the Cliffs of Moher are one of the most magnificent scenes in the country. They rise to a height of 656 feet (200 m) and are 5 miles (8 km) long.

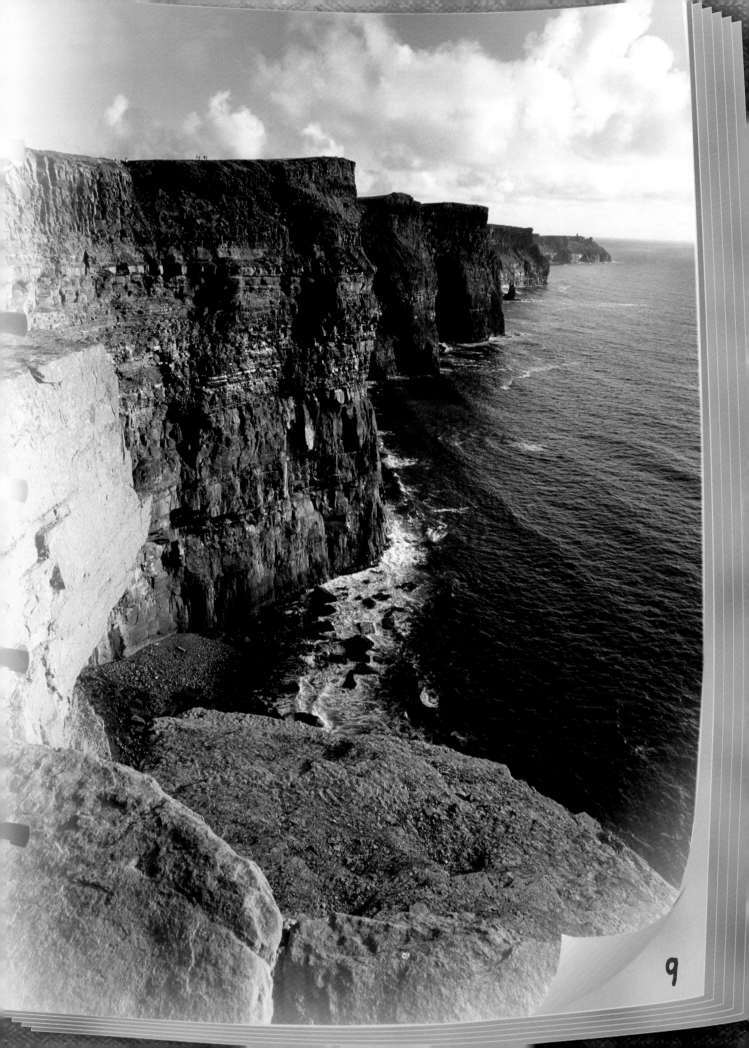

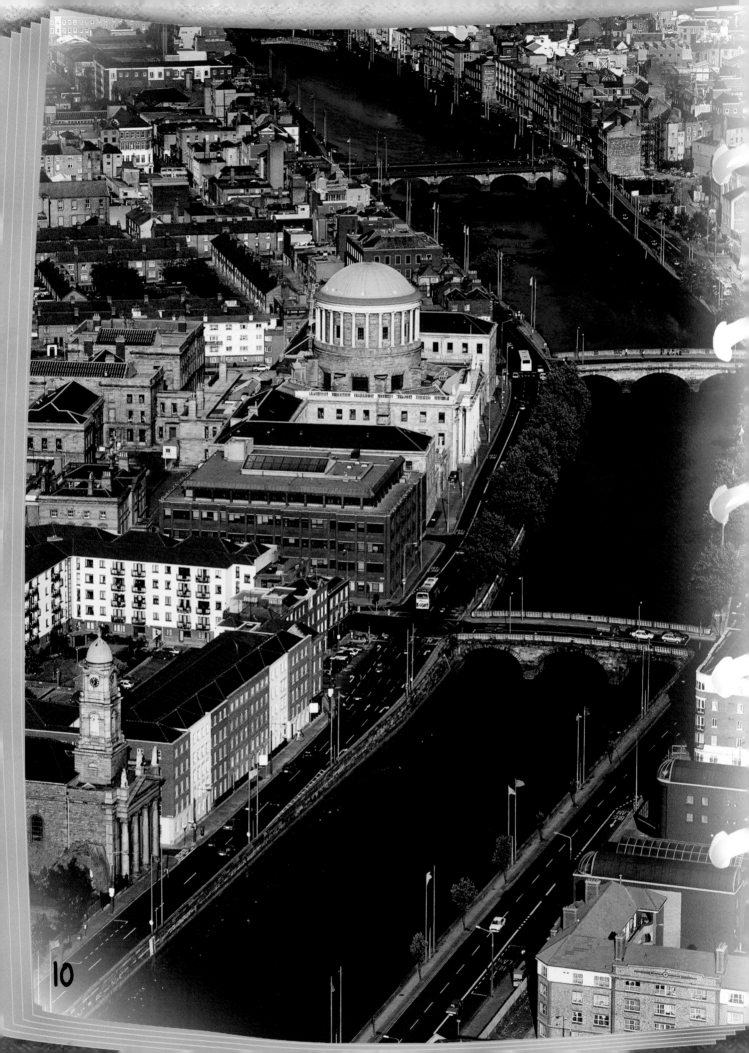

also important. Ireland has plenty of salmon, cod, mackerel, and lobster. Since the mid-1900s, agriculture has become less important as manufacturing has grown. Today factories make textiles and clothing, chemicals and medicines, and computers and other electronic equipment. Ireland also has a lot of peat, a kind of mineral used as fuel for heat and generating electric power.

For a long time, Ireland's economy depended on agriculture. However, the landlords who owned the land became rich, while the farmers remained poor. Many people were forced to move to the United States and other countries because of this poverty. Ireland's economy began to grow in 1973, however, when Ireland joined the European Union (EU). The EU is a group of European countries that help one another. It has helped Ireland to sell Irish products to more countries at better prices. Between 1993 and 1998, Ireland's economy grew by 51 percent. This big improvement, which is sometimes called the Celtic Tiger, is mainly because of Ireland's success in selling its products overseas.

Many foreign banks and financial companies have set up offices and invested in Ireland, especially in its capital, Dublin. Pictured here is Dublin's busy center, which has the famous River Liffey running through it.

The Artist Jack B. Yeats

The painter Jack Butler Yeats (1871–1957) was born in London to Irish parents. He grew up in Sligo, in northwestern Ireland. His father, John B. Yeats, was also an artist. His older brother, William Butler Yeats, was a famous poet.

Jack B. Yeats

Jack B. Yeats studied art in London in the 1880s. There he worked first as an illustrator, drawing for books and newspapers. He used watercolor in his drawings. Yeats continued to work as an illustrator until about 1910. Later he began using oil paint. His oil paintings were very successful. Several of them were shown in the famous Armory exhibition in New York City in 1913.

Yeats's memories of his childhood in Sligo inspired many of his paintings. Sligo has rugged mountains and peaceful lakes. Most of Yeats's pictures show this natural beauty of the countryside and the seaside, a style of art known as landscape. His pictures of Ireland inspired patriotism among his

countrymen, especially after the Republic of Ireland became independent.

In *On to Glory*, Yeats creates a sense of adventure and freedom by using images of a horse and a road, which are images that appear often in his work. In this painting, a golden-haired child is leading a magnificent chestnut horse toward the sea. The landscape recalls Sligo, Yeats's childhood home.

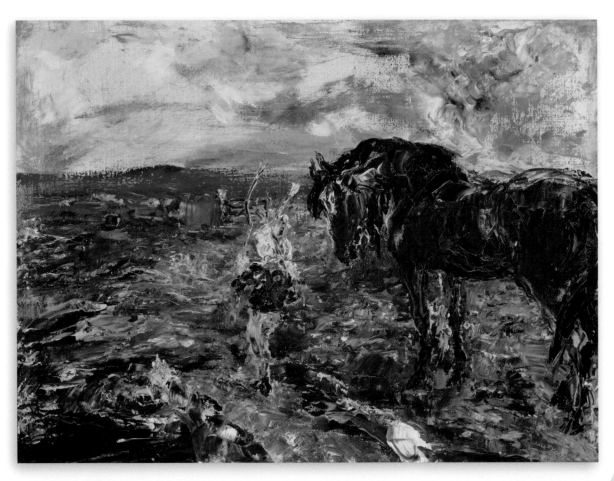

Yeats painted *On to Glory* around 1911. It is oil on canvas. The painting measures 18" x 24" (46 cm x 61 cm). It was one of his earlier oil paintings. As time went on, Yeats became bolder in his use of color.

Map of Ireland

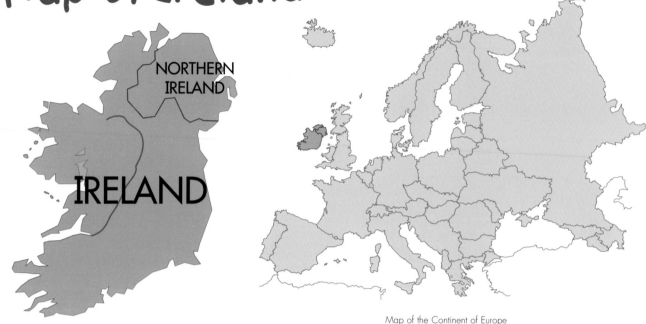

Map of the Continent of Europe

Ireland is an island in northwestern Europe. It is near Britain. To the east the Irish Sea and Saint George's Channel separate Ireland from Britain. The Atlantic Ocean bounds Ireland in the north, the west, and the south.

Politically the island is divided into the Republic of Ireland and Northern Ireland. The Republic of Ireland consists of four provinces. They are Connacht, Leinster, Munster, and Ulster. These provinces consist of 26 counties and cover 27,137 square miles (70,284 sq km). Northern Ireland, which is part of Great Britain, is in Ulster and has six counties. Ireland is also known as the Emerald Isle, because it is a beautiful island with plenty of green farmlands and mountains.

1

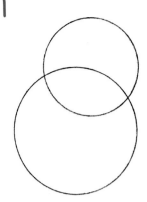

Start by drawing two circles. Notice that one circle is larger than the other one. Notice, too, the position of these circles. These shapes are guides to help you draw a map of Ireland.

2

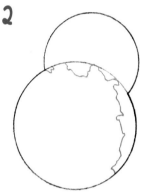

Erase the bottom of the small circle. Next draw a long squiggly line inside the large circle. Try as best you can to follow the shape of the line shown. Add a small squiggly line beside it.

3

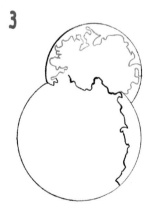

Erase the top of the large circle guide. Notice that the line you just drew in the middle does not quite reach all the way across. Add another long squiggly line, this time in the small circle. Notice the lines in this step connect to the lines you drew in the bigger circle.

4

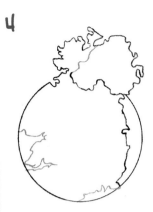

Erase the top of the small circle. Draw a wavy line that connects the top of the map with the line that does not quite reach all the way across. Well done. You have just drawn Northern Ireland! Next draw more squiggly lines within the large circle.

5

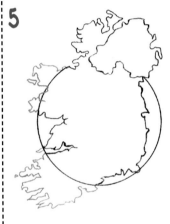

We have a few more squiggly lines to draw and then we are finished! Draw these lines on the outside edges of the large circle as shown. Notice that they connect to the lines already drawn inside the circle.

6

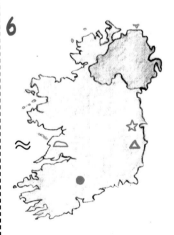

Erase the rest of the guide for the big circle. Add the small islands around Ireland as shown. Next shade the area that is Northern Ireland. Draw the map key as shown, and you are done!

☆ Dublin
△ Glendalough
⌓ Cliffs of Moher
● Blarney Stone
≈ Atlantic Ocean

The Flag of Ireland

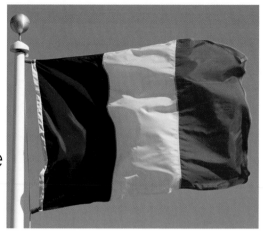

The Republic of Ireland's flag has three vertical stripes. They are green, white, and orange. The green stripe stands for Catholics, who make up the majority. The orange stripe represents Protestants, who make up a smaller group. The white stripe stands for their unity. The flag was made popular by a group called Young Ireland, which was made up of both Catholics and Protestants. The group wanted all Irish people, regardless of religion, to fight for freedom from Great Britain.

The Irish Euro

The Irish pound, called a punt in Gaelic, was made in 1928. It was the first currency of an independent Ireland. It was used until 2002, when Ireland began using the euro. The euro shows the EU map on one side. On the other side is the year the coin was made, a harp, and the word Éire, which means Ireland. The 12 stars on this coin stand for the 12 countries using the euro in 2002.

Flag

1

Draw two rectangles. Notice that one is thin and long and the other is wide and short.

2

Inside the tall rectangle draw the pole as shown. Next, using the bigger rectangle as a guide, draw the wavy lines for the flag.

3

Erase the rectangles. Draw lines to connect the flag to the flagpole. Add details to the pole. Add a wavy line to the right of the pole. Draw three wavy lines on the flag. Add extra lines.

4

Finish with shading. Make the stripe on the left the darkest. Leave the middle one white.

Irish Euro

1

To draw the Irish euro, begin by drawing three circles as shown. Notice that the two outer circles are close together.

2

Add twelve stars within the two middle circles. Place the stars as you would place numbers on a clock.

3

Draw the harp in the center circle. Look at the photograph on the opposite page for help. You can get as detailed as you like.

4

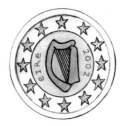

Next add the word "EIRE" to the left of the harp. Add "2002" for the date on the right. Finish by shading in the stars, the harp, and the center of the coin.

The Shamrock

"Shamrock" comes from the Gaelic word *seamróg*, which refers to the plant's three leaves. The shamrock is a plant that has become a special symbol of Ireland. Many Irish wear a shamrock on Saint Patrick's Day. Legend says that Saint Patrick, Ireland's patron saint, picked a shamrock to explain the Holy Trinity. This refers to the Christian belief that God is made up of three persons who are one, the Father, the Son, and the Holy Spirit.

The Harp

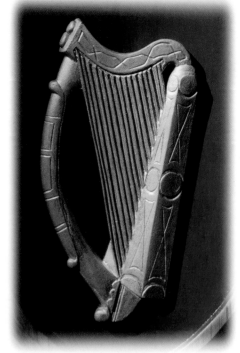

The harp is one of the oldest musical instruments with strings. It is played by plucking the strings with both hands. The harp has been a popular musical instrument in Ireland since the tenth century. Since then it has become an important symbol of Ireland. The harp appears on Ireland's euro coin, presidential flag, and coat of arms.

Shamrock

1

Begin by drawing a vertical line. Draw a dot in the center of the line.

2

Next draw two more lines in the shape of the letter X. Make sure that your lines cross over the dot.

3

Draw lines from the dot that go up and out, and that curve back to just below the top of the line. Two curves together should look like a heart.

4

Erase the straight lines. To finish you can shade the leaves and then use your eraser to make the center of the leaves and the dot in the middle white.

Harp

1

Begin your harp by drawing an upside-down triangle.

2

Look at the drawing carefully and add the shapes to the top of the triangle. You can use the photograph on the opposite page to help you. Add the lines to the bottom of the triangle as shown.

3

Erase the straight line at the top of the triangle. Draw two small circles at the top of the drawing. Add four lines for strings inside the triangle. Add the straight and curved lines, including four round shapes at the bottom, around the triangle.

4

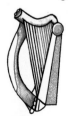

Add more strings to the harp. Add the final touches to the harp, adding as much detail as you like. Look at the photograph to help you. Finish with shading. Well done!

The Connemara Pony

Connemara is an area in western Ireland where much of the land is barren. According to legend, a group of Spanish warships sank near the Connemara coast during the 1500s. Horses in the sinking ships swam to the shore and bred with native ponies. This breeding resulted in a special kind of animal, the Connemara pony. These ponies can survive in a place that is rocky and has few plants, such as Connemara.

The Connemara pony is small, but strong. It measures between 13 and 15 hands (1.3 m–1.5 m). These ponies are known to be limber, with a sweet temperament that makes them good ponies for children to ride. They are also known to be great jumpers. Today Connemara ponies can be found not only in Ireland, but also in many other countries.

1

Begin by drawing a wavy line for the pony's back and neck.

2

Add three circles for the body. Notice that the middle circle is slightly larger than the other two. Add two more small circles for the head.

3

Draw the two outside legs first. For each leg, draw a line. Then add the ovals and circles as shown. The small circles are the knees and the hooves. Draw two lines for the other legs.

4

Erase the guidelines for the first two legs. Then add shapes as before to form the other two legs. Draw a slightly curved line for the bottom of the neck. Add an oval shape for the nose.

5

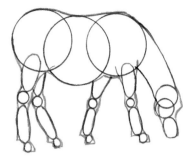

Erase the guidelines on the other two legs. Draw lines that connect all the circles and ovals in the legs, the body, and the head. At the bottom of the legs, make the hooves a little pointed as shown. Add a small curved line in one of the circles at the head as shown.

6

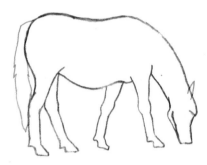

Erase the oval and circle guides, leaving the outline. Add an ear and eye. Once you draw the tail, you have nearly finished drawing the Connemara pony!

7

For the final touches, you can add some shading. Also, draw in some hair, called the mane, at the neck. Add hair to the tail, too. Add some grass for the pony to eat.

Newgrange Passage Grave

There is an ancient site in eastern Ireland called Newgrange Passage Grave. It was built around 3200 B.C. The bones and the ashes of dead kings might have been buried in it. It is called a passage grave because of its narrow path, which leads to where the people were buried. The grave was built in such a way that, when the sun comes out on December 21, a ray of sunshine enters through a space in the roof at the entrance. The ray lights up the inside of the burial chamber. This happens only every December 21, at the beginning of winter, which is called the winter solstice. Nobody knows why the passage was built this way, but it appears to be a solar observatory, or a place to watch sunlight.

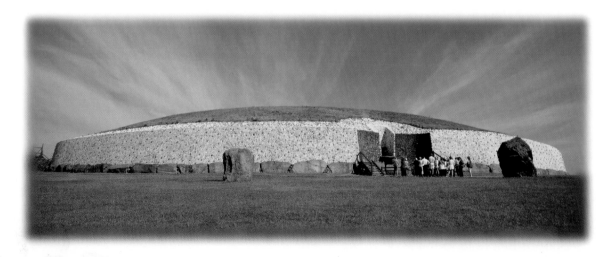

1

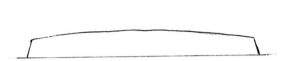

Start with a horizontal line. Add three lines to make the slightly curved shape shown. Notice that the right and left sides of this shape do not reach all the way to the end of the line. You have drawn the base of the passage grave at Newgrange.

2

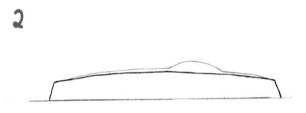

Next add a wavy line on top of the shape. This is the beginning of the roof. The line you draw should not quite reach the sides of the base. It should rise into a bubble shape toward the right-hand side.

3

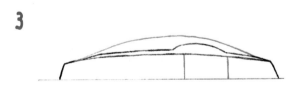

To complete the roof, draw a line in the shape of an arc. Notice again that this shape does not reach the sides of the line you drew in the first step. Next add two vertical lines below the bubble shape. This is the entrance to the passage grave.

4

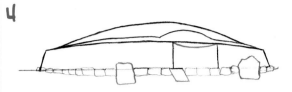

Draw a lot of shapes on and around the first horizontal line that you drew. These shapes should be different sizes. They will be the rocks that surround the passage grave. Draw a line that curves downward at the top of the entrance. Next draw a small slanted shape at the bottom left of the entrance. This will be stairs.

5

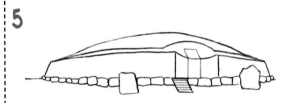

Erase extra lines. Mark the stairs in the shape you just drew using horizontal lines. Next draw two vertical lines in the entrance. When you reach the top of the entrance, draw a straight line slanting slightly to the left. Do this on the other side and join the lines at the top with a short horizontal line. You have just drawn the door.

6

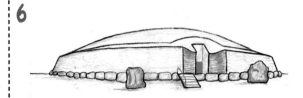

In the door, add a vertical line as shown and erase the curved line in the middle. Next draw a rail at the stairs. You can finish by shading the areas as shown.

The Rock of Cashel

The buildings known as the Rock are in the town of Cashel, located in Tipperary in southern Ireland. They consist of a round tower, a roofless monastery, a hall, a cathedral, and a chapel. The area is surrounded by stone walls. The Rock of Cashel was built in the fourth century as a fortress, or a place meant to protect people from their enemies. The kings of Munster lived there. Munster is a province that covers most of southern Ireland. The castle was built to last a long time, protecting kings against different enemies. The kings of Munster fought very hard to rule the entire country. Brian Boru was the first Munster king to succeed. He became the first high king of Ireland in 1002, which meant that he ruled other Irish kings.

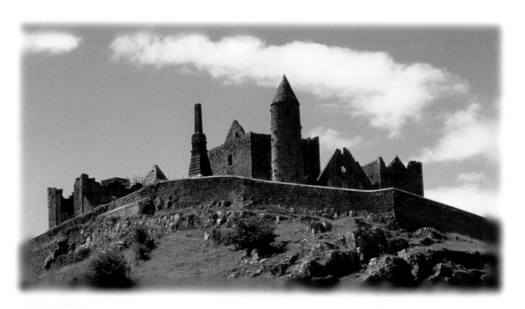

1

Begin by drawing a horizontal line. Draw a rectangle on the right. The rectangle is hidden a little by a triangle beside it. Draw a curved line. Draw a triangle on the left. It is a little hidden by the curved line.

2

Erase part of the horizontal line. Add five more rectangular shapes. Notice that some are bigger than others. Add a line that slopes downward on the right.

3

On the left side of your drawing add another line that slopes downward. Add the shape on the left using straight lines.

4

The shapes you have drawn are guides for the buildings in the castle. Carefully draw the outline of a building within each guide block as shown.

5

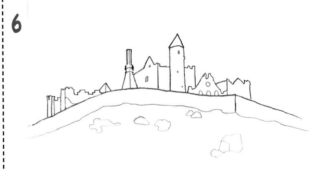

You can now erase the tops of the blocks. Under the last building on the right, draw lines as shown.

6

Erase the extra line under the lines you just drew. Draw a line under the big long curved line that is now at the bottom of your drawing. You have drawn the wall that surrounds the castle buildings. Add lines and details, such as windows, to the buildings. Add rocks below the wall you just drew.

7

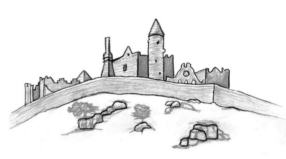

Using the photograph on the opposite page to help you, add as much detail as you like. Finish by shading as shown. Notice that the shading is darker in some places than in others.

The Vikings

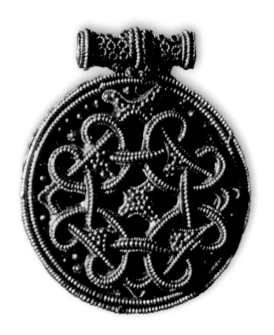

It is believed that the first Vikings sailed to Ireland from Norway around A.D. 795. They came looking for wealth and new lands to rule. They were attracted by Ireland's monasteries, which had plenty of ornaments and church objects that were of high value. Most Vikings attacked Ireland to steal these objects and then left. However, some of them stayed. Those who stayed established the country's first towns in Dublin, Limerick, Cork, Waterford, and Wexford in the early 900s. Some of today's Irish people are descendants of the Vikings who settled here.

We can learn about the Vikings from the tools, the weapons, and the jewelry that they buried with their dead relatives. They believed that the dead could enjoy these things in another world. Many such articles were found in Wood Quay in Dublin, where the Vikings first settled in 841. The neck pendant shown here is among the jewelry the Vikings wore.

1

Start by drawing two circles, one inside the other. Draw a dot at the center of the circles.

2

Add a small rectangle at the top. This will be the bar at the top of the pendant. Next draw four small circles. If they were positioned like the numbers on a clock, they would be at 12, 3, 6, and 9.

3

Place a dot in the center of each small circle. Connect the four dots with straight lines. This makes a square shape. This square will serve as a guide to drawing the patterns in the pendant.

4

Draw slightly curving lines at the sides of the bar at the top. Next draw two more squares in the square shape you have just drawn. The first one will be resting on a flat edge. The other one will be on its point, just like the very first one that you drew.

5

Erase extra lines. Draw two vertical lines in the middle of the bar. Add very small circles between these lines and at the sides of the bar. Add more circles to the outer edge of the pendant. Next start to draw a pattern of loops.

6

Continue to draw the pattern of loops as shown. Also continue to add small circles to the outer edge of the pendant. Next add some circles in the center.

7

Draw small circles over the loops. Erase the loop lines, leaving only the circles. Erase the two center squares. Add straight lines coming from the center to the outer square. Cover the top bar with small circles. Make the four circles that you drew in step 2 smaller as shown.

8

Cover all remaining straight lines with small circles. Shade these circles darker so that they stand out. Finish by shading the pendant lightly.

Christianity and the High Cross

Christianity was introduced to the Celts in Ireland around 431 B.C. Although the Celts believed in magic and fairies, they accepted Christianity when missionaries preached it to them. Saint Patrick was the most successful missionary in converting the Irish to Christianity.

From A.D. 550 to 750, Irish monasteries were important learning centers. Christian monks lived and worked in monasteries. They promoted writing and reading and made many works of art, including monuments of crosses. High crosses, or Celtic crosses, are unusual because they combine the symbol of the Sun, which the Celts worshipped, with the Christian cross. Today the Celtic cross is a well-known symbol of Irish Christianity. This high cross, found in Clonmacnoise, is special because pictures about the life of Saint Patrick are carved on its panels. It stands 13 feet (4 m) high. Clonmacnoise is a monastic site in central Ireland.

1

Draw a long rectangle. Divide it into four smaller rectangles as shown. You will use this shape as a guide to draw the Celtic cross.

2

Draw a line down the middle of the long rectangle, through the top three rectangles as shown. Draw a circle in the middle of the top two rectangles. Next add two slightly curved lines at the edges of the bottom rectangle.

3

Draw four half circles on the inside of the circle. You have begun to draw the top of the cross.

4

Next draw two more circles. The first should be drawn around the original circle. Then add a smaller circle in the middle of the two circles. Draw four lines to make the shape of a *T* in the bottom rectangle.

5

Erase the guidelines of the rectangles, leaving the lines shown. The lines you are left with can be used as guides.

6

Draw lines on each side of the guides as shown. You can see that the cross is beginning to take its shape! Add small circles to the bottom rectangle.

7

Erase the four center guidelines and the extra lines at the edges of the outer circle as shown. Add the extra circles and lines at the top of the cross.

8

Using the photograph on the opposite page for help, add as much detail as you like. Finish with shading. Well done, you did a great job!

Blarney Castle

Blarney Castle is located in County Cork in the southern part of Ireland. The castle was destroyed a long time ago. Its strongest part, the keep, still stands today. Dermot McCarthy, king of Munster, built the castle in 1446.

Many people visit the castle to kiss a block of limestone set in the wall of the castle's tower. The block is called the Blarney Stone. According to legend, there was once a king who saved an old woman from drowning. To reward the king, the woman put a spell on him. If the king kissed the stone while under the spell, he would be able to speak in a way that would make everybody agree with him. Today people kiss the Blarney Stone hoping that they, too, will be able to speak convincingly.

1

Start with a horizontal line. Then add a tall rectangle. These guides will help you to draw Blarney Castle.

4

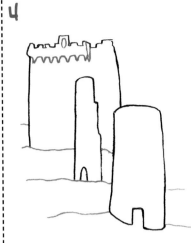

Erase the guidelines. Add a squiggly line and an oval shape at the top of the larger building at the back. Draw vertical lines. Add wavy lines for the landscape as shown.

2

Draw a wide rectangle behind your first rectangle. Part of it is hidden behind the first one. Draw another rectangle at the front as shown.

5

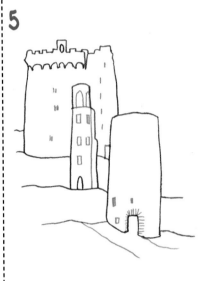

Add rectangles, arches, and lines for windows and doors. Add a vertical line to the middle building. Add little lines as shown around the door in the front building. Draw slanted lines as shown for the path.

3

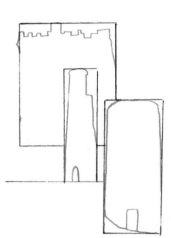

Carefully draw the outline of the buildings within each rectangle as shown. Draw small shapes for the doors on the two buildings at the front.

6

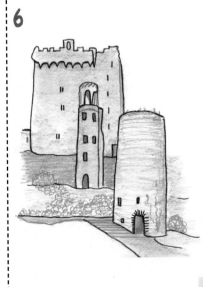

Add a curved line beside the path you have just drawn. Finish by adding detail and shading. Notice that the shading is darker in some parts of the drawing.

31

Trinity College and the Book of Kells

One of Ireland's most important schools is Trinity College in Dublin. Queen Elizabeth I of Great Britain founded the college in 1592. It was established as a school for rich Protestants from England who lived in Ireland. Roman Catholics were not allowed to attend the college until after 1970. Today Trinity College accepts students of all religions. Many people visit the university to see the Book of Kells, which is kept in its library. Monks wrote the book around A.D. 800. The monks might have started writing it in Iona, Scotland, but they finished it in the town of Kells, Ireland. It is therefore associated with, and kept in, Ireland. The book contains the four Gospels, which tell stories about Jesus. It also has beautiful and colorful drawings of animals, people, angels, and symbols.

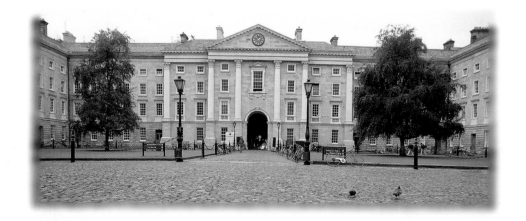

1

Start by drawing a long rectangle. Draw a vertical line down the middle of the rectangle. Notice that the line continues above the rectangle. You now have two rectangular shapes.

2

Draw four vertical lines as shown. Draw a slanted line from each corner of the large rectangle.

3

Draw lines to form the top of a triangle in the middle as shown. Next add two horizontal lines at the top of the rectangles as shown.

4

Erase the center vertical line. Erase the lines above the little horizontal lines. Draw a small roof on each side as shown.

5

Draw a circle inside the triangle. Draw lines inside the three main buildings. Add an arch for the door. Draw two trees. Add lines at the front and at the top sides as shown.

6

Add extra lines to the fronts of the buildings as shown. Add lines and shapes for the chimneys to all of the roofs. Copy as best you can the two lampposts. Use the photograph for help.

7

Add rows of shapes for the windows. Add three horizontal lines across the tops of the three center buildings. Add a triangle in the middle. Add the small fence posts, railings, and the small lampposts by the arched doorway.

8

Add as much detail to your picture as you like. Finish by shading. Notice where some of the shading is darker. Great job!

33

The National Famine Monument

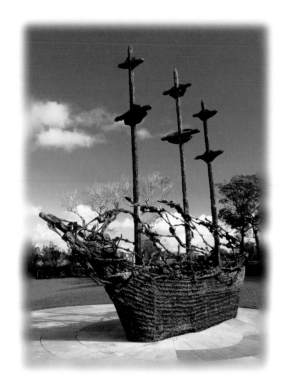

The National Famine Monument is located in Mayo, in the west of Ireland. The monument honors the two million Irish people who either died from hunger and diseases or were forced to leave the country in the 1840s. This terrible period is known as the Great Famine. From 1845 to 1848, Ireland's potato crop failed because of a plant disease called blight. Back then, most Irish people depended on potatoes for food. As a result of the failing crop, about one million people died of hunger. More than one million people left the country. Many went to the United States, Canada, England, and Australia. However, many died from diseases on the ships during the long journey. This is why the ships came to be known as coffin ships. The sculpture shows skeletons to represent those who died. The monument was built to remember not only the people who died, but also those who survived the Great Famine.

1

Start by drawing two triangles as shown. These are guides for you to draw the boat.

2

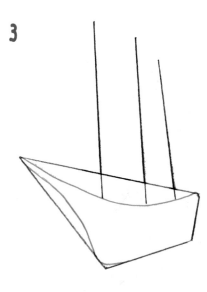

Erase the line between the two triangles. Next add three lines. These will be the masts of the ship. Notice that they are not completely straight. Be sure to draw the lines at a slight angle as shown.

3

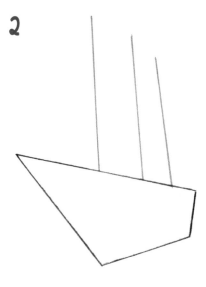

Draw two long curved lines at the top and the side of the guides as shown. Add a much smaller curved line at the bottom of the boat.

4

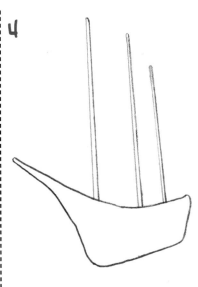

Now you can erase the guide shape, leaving the curved lines. Make your masts wider by adding three more lines. Make sure the lines curve to meet at the top of the posts.

5

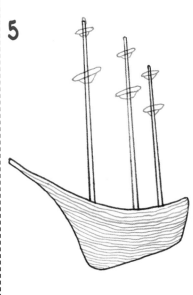

Add six thin shapes, two to each mast. Below these shapes, add small curved lines. Add a curved line to the top of the first mast. Draw a lot of wavy lines on the body of the boat.

6

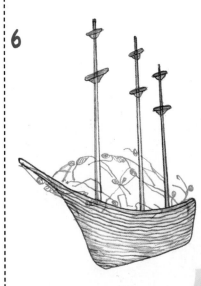

Draw a lot of squiggly lines. These will be your skeletons. Copy them as best you can. You can finish by shading your drawing.

Thatched Roof Cottages

In the past, most people in Ireland lived in simple cottages with roofs made of straw and grass, or what is called thatch. Today most cities and towns have modern houses. However, many people in rural parts of Ireland still live in thatched roof cottages. This is especially true in the Aran Islands, located at the mouth of Galway Bay. Most of the 2,000 people there have preserved the old ways of Irish life. They live in thatched roof cottages without telephones or electricity. Another way that people in the Aran Islands have preserved the old way of life is by speaking Irish, or Gaelic. Places where people speak Irish as their first language are called Gaeltachts. These areas can be found in parts of Mayo, Galway, Kerry, Cork, and Waterford. Thatched roof cottages stand for Ireland's link to its past.

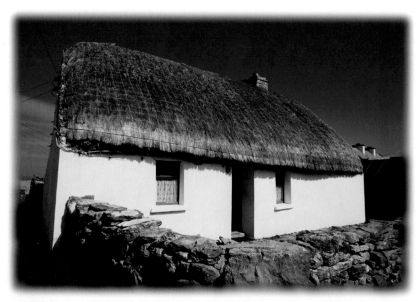

1

Start by drawing the shape shown. This will be the outline of your thatched roof cottage.

2

Draw a slanted line across the middle part of the shape you just drew. The line slants slightly downward from left to right. This will be your guide to drawing the thatch roof.

3

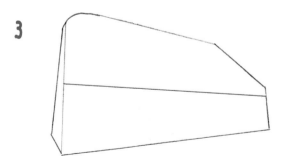

Draw a vertical line from the bottom left corner of the house to nearly the top of the roof. This is the side of the house, and it will give your drawing depth. Erase the extra line at the side.

4

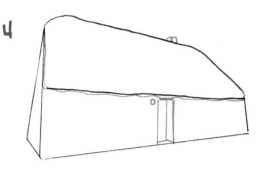

Draw a rough vertical line at the top left-hand side of the house. Connect it with a rough line you will draw underneath the roof guideline you drew in step 2. Make sure it curves at the left side of the roof. Add a small chimney at the top right side of the roof. Add a door and a small circle beside it.

5

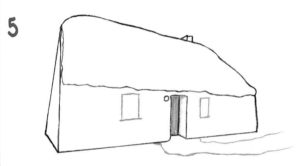

Erase extra lines on the roof and in the doorway. Draw rectangles on either side of the door for windows. Notice that the bottom lines extend. Shade the inside of the doorway. Draw wavy lines for the pathway leading up to the house.

6

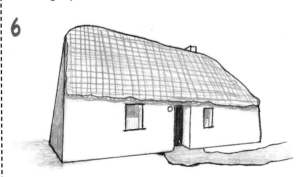

Draw horizontal and vertical lines that form crisscrosses on the roof. Add lines to the windows. You can finish by shading your drawing.

Daniel O'Connell

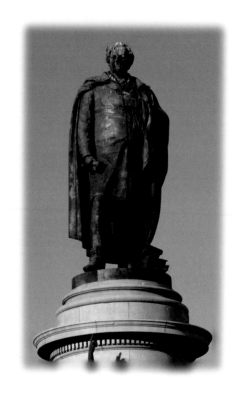

 Daniel O'Connell (1775–1847) is known as the Liberator of Ireland because he fought for his country's freedom from Britain. Born in Kerry, O'Connell was the nephew and heir of an Irish landowner. In the early 1800s, he became a lawyer, and he worked to remove the law that made Ireland a part of Britain. He also formed the Catholic Association to push for the rights of Irish Catholics. In 1828, he was elected to Parliament, but the Penal Laws prohibited him from doing his job because he was Catholic. The Penal Laws stated that Catholics could not hold elected office. These laws made it hard for Catholics to own land or to go to university. However, the British were afraid the Irish would side with O'Connell and rebel against them. The British passed an act in 1829 which cancelled the Penal Laws and allowed O'Connell to take his seat in Parliament. Today a great monument stands in Dublin to remember O'Connell as a hero. The statue was designed by John Foley and was completed in 1882.

1

Use ovals to draw the shape of a man. Use a big oval for the main body and smaller ones for the head, arms, and legs. Draw circles for the feet. See how the ovals for the arm on the right cross over each other. Draw three lines for the statue's base.

2

Connect all the ovals to make an outline of a body. Draw in the outline of the feet as shown. Use two circles to show where the hands will go.

3

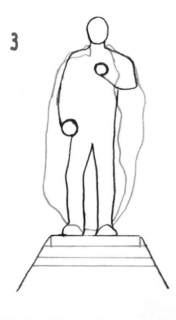

Erase the oval guides and leave the outline. Add the wavy lines as shown to draw the cape. Add a line to the foot on the left. Add three horizontal lines to the base of the statue as shown. Add two small vertical lines.

4

Erase extra lines. Draw lines for the jacket and arms. Notice that the hand at the right disappears under the vertical line you draw for the opening in the suit. Draw the hand and the document on the left side.

5

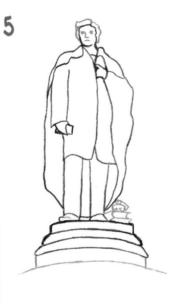

Erase extra lines. Next add the statue's eyes, nose, mouth, and hair, as shown. At his feet, copy the squiggly lines to draw the books and the maps. Add an extra curved line at the bottom of the base. Outline the sides of the base and erase the guides.

6

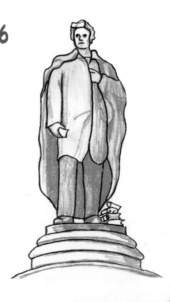

Finish by shading your drawing. Well done! You have just drawn the statue of Daniel O'Connell!

39

James Joyce and the Martello Tower

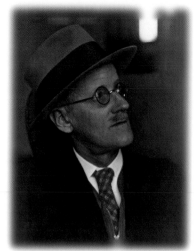

Many Irish writers have made important contributions to English literature. Some famous Irish writers are Jonathan Swift, Oscar Wilde, Samuel Beckett, and Iris Murdoch. The novelist James Joyce is one of the most important Irish writers of all time. He is one of Ireland's best-known and most-respected literary figures. Joyce was born in Dublin on February 2, 1882. He was poor and unknown until his novel *Ulysses* was published in 1922. In this book, one of the characters lives in Martello Tower in Sandycove, Dublin. In fact, Joyce himself lived in the tower for one week in 1904. Today the tower houses a museum in his honor. Joyce's other works include *Finnegan's Wake* and *Dubliners*. Joyce died on January 13, 1941.

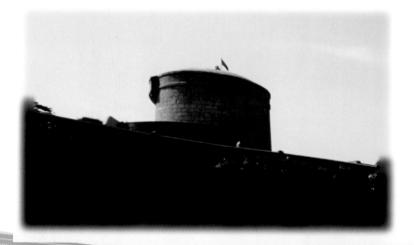

1

Start with a rectangle. This will be your guide to drawing the Martello Tower.

4

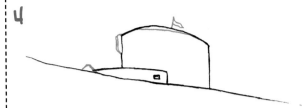

Add a small flag at the top of the tower. Draw a curved line at the roof. Add the shape shown on the top left side of the tower. Finish this step by adding a small triangular shape at the bottom left-hand side of your drawing.

2

Draw a long slanted line through the bottom of the rectangle. Make sure that you angle the line so that is higher on the left side and lower on the right side. Draw curved lines at the top of the rectangle.

5

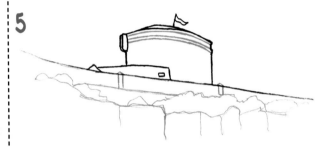

Add three curved lines at the top of the tower. Notice that two are closer together. Add the details shown. These are a fence, some rocks, and bushes.

3

Erase the top and the bottom parts of the rectangular guide as shown. This is your tower. Add the shape that is shown in front of the tower, making sure to draw a tiny rectangular shape on the inside.

6

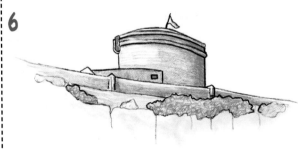

Erase extra lines. Finish by shading in the parts as shown. Use both dark and light shading. Well done! You have finished Joyce's Martello Tower.

The Children of Lir

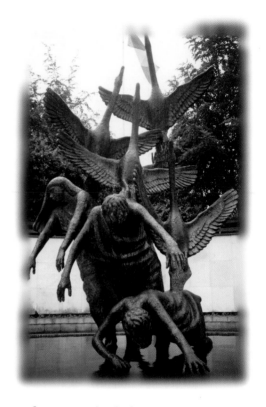

One of the things Ireland is most famous for is its long tradition of storytelling. This tradition has has produced many wonderful myths and legends. One of the best-known myths is that of the Children of Lir. According to an Irish folktale, a king named Lir loved his four children very much. This made the children's stepmother jealous. She took them to a lake and cast a spell on them that would last 900 years. The children turned into white swans with human voices. The stepmother said the spell would be broken at the sound of a bell that would change Ireland. When 900 years had passed, the swans flew back home. As soon as they heard a monk ringing a church bell, they became humans again. By then, however, they were very old and everyone they had once loved had died. The sound of the bell that changed Ireland stands for the coming of Christianity. The statue of the Children of Lir is in Dublin's city center.

1

Study the photograph of the statue to understand what you see. There are three bodies and four birds. Draw four shapes as shown.

2

Add the three long shapes above. Notice that these shapes curve in a little at the top.

3

Add ovals for heads to the three bottom ovals. Add smaller ovals to the other four shapes. Draw four curved lines through these four shapes as shown.

4

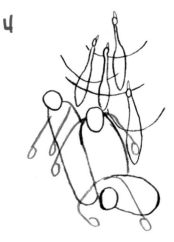

Erase extra lines on the bottom three shapes. Draw lines for the arms of these three bodies. Make ovals for the hands. Add four shapes coming from the heads of the bird shapes. These are their beaks.

5

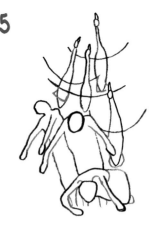

Draw the birds' tails around the guides as shown. Finish off the arms and feet by adding extra lines as shown. Erase extra lines.

6

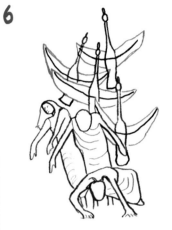

Erase tail guides. Next, add the birds' wings. Study the series of curved lines and copy them as best you can. Add details to the bodies as shown. Do not forget to draw the hands and erase extra lines.

7

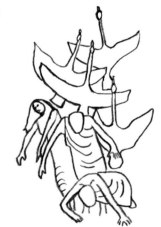

Erase any unnecessary lines. You have nearly completed the Children of Lir statue. Add the final hand to the center body.

8

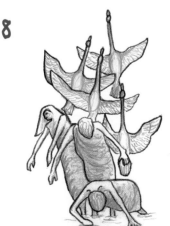

Finish by adding detail and shading. Notice that the wings have feathers. These are shown as small lines within each wing.

43

Timeline

6000 B.C.	The first settlers come to Ireland.
500 B.C.	The Celts begin attacking Ireland.
A.D. 431	Christianity is introduced in Ireland.
795	The Vikings begin attacking Ireland.
1014	Brian Boru, high king of Ireland, beats the Vikings.
1160s	The Normans attack Ireland.
1541	England's King Henry VIII is officially announced king of Ireland.
1801	Ireland becomes part of Great Britain.
1845–1848	One million people die from hunger when Ireland's potato crop fails. Another one million people leave Ireland.
1921	A treaty divides Ireland into two parts.
1949	The southern part of Ireland becomes an independent republic. Northern Ireland remains a part of Great Britain.
1973	The Republic of Ireland joins the European Union.

Ireland Fact List

Official Name	Republic of Ireland
Area	27,137 square miles (70, 284 sq km)
Population	3,883,159
Capital	Dublin, population 952,700
Most-Populated City	Dublin
Industries	Clothing, textiles, chemicals, medicines, computers, and other electronics
Agriculture	Beef, dairy, barley, sugar beets, potatoes, and wheat
National Plant	Shamrock
National Dance	Irish dancing
National Sport	Hurling
National Anthem	"The Soldier's Song"
Languages	English and Irish (also known as Gaelic)
Highest Mountain Peak	Carrantuohill, 3,414 feet (1,041 m)
Longest River	Shannon, 230 miles (370 km)
National Holiday	Saint Patrick's Day, March 17

Glossary

burial chamber (BER-ee-ul CHAYM-bur) A room where bodies are buried.

cathedral (kuh-THEE-drul) A large church run by a bishop.

Catholics (KATH-liks) People who belong to the Roman Catholic faith.

Christian (KRIS-chun) Following the teachings of Jesus Christ and the Bible.

coat of arms (KOHT UV ARMZ) A picture, on and around a shield or on a drawing of a shield, that stands for a family or a country.

coffin (KAH-fin) A box that holds a dead body.

counties (KOWN-teez) Smaller areas into which a country is separated.

customs (KUS-tumz) Practices common to many people in an area or social class.

descendants (dih-SEN-dents) People who are born of a certain family or group.

disease (duh-ZEEZ) An illness or a sickness.

emerald (EM-reld) Bright green.

famine (FA-min) A shortage of food that causes people to go hungry.

foreign (FOR-in) Outside one's own country.

fortress (FOR-tres) A strong place that can be defended against attacks.

Gospels (GOS-pulz) Four books that are part of the Bible.

illustrator (IH-lus-tray-ter) A person who draws pictures that go with a story.

inherit (in-HER-it) To receive something after the former owner dies.

invested (in-VEST-ed) To have put money into something, such as a company, in the hope of getting more money later on.

isle (EYEL) An island.

legend (LEH-jend) A story, passed down through the years, that cannot be proven.

liberator (LIH-buh-ray-ter) Someone who sets something free.

limestone (LYM-stohn) A kind of rock made of the bodies of small ocean animals.

literature (LIH-tuh-ruh-chur) Writings such as books, plays, and poetry.

majority (muh-JOR-ih-tee) The larger number.

mineral (MIH-ner-ul) A natural element that is not an animal, a plant, or another living thing.

missionaries (MIH-shuh-ner-eez) People sent to do religious work in another country.

monastery (MAH-nuh-ster-ee) A house where people who have taken vows of faith live and work.

novel (NAH-vul) A long story about made-up people and events.

novelist (NOV-list) A person who writes novels.

parliament (PAR-lih-mint) The group in Ireland that makes the country's laws.

patriotism (PAY-tree-uh-tih-zum) Pride in one's country.

patron saint (PAY-trun SAYNT) A special saint who is thought to help an individual, a trade, a place, a group, or an activity.

pendant (PEN-dent) A small object often worn hanging from the neck.

peninsula (peh-NIN-suh-luh) An area of land surrounded by water on three sides.

poverty (PAH-ver-tee) The state of being poor.

Protestants (PRAH-tes-tunts) People who belong to a Christian-based church but are not Catholic.

provinces (PRAH-vins-ez) The main parts of a country.

republic (ree-PUB-lik) A form of government in which the authority belongs to the people.

rural (RUR-ul) In the country or in a farming area.

Scandinavia (skan-dih-NAY-vee-uh) Northern Europe, usually Norway, Sweden, and Denmark.

scenic (SEE-nik) Beautiful to look at.

site (SYT) The place where a certain event happens.

survived (sur-VYVD) Stayed alive.

textiles (TEK-stylz) Woven fabrics or cloths.

tourists (TUR-ists) People visiting a place where they do not live.

traditions (truh-DIH-shunz) Ways of doing things that have been passed down over time.

watercolor (WAH-ter-kuh-ler) A paint made by mixing color and water.

winter solstice (WIN-ter SOL-stes) The beginning of the winter in the northern half of Earth.

Index

Web Sites

Due to the changing nature of Internet links, PowerKids Press has developed an online list of Web sites related to the subject of this book. This site is updated regularly. Please use this link to access the list:

www.powerkidslinks.com/kgdc/ireland/

SO YOU THOUGHT YOU COULDN'T DRAW™

By SANDRA McFALL ANGELO

DISCOVER ART PUBLICATIONS / SAN DIEGO/ CA

So You Thought You Couldn't Draw™

Published by: Discover Art, P.O. Box 262424, San Diego, CA 92196
Call Toll Free: 1 (888) 327-9278. Fifth edition.
DiscoverArtWithSandra.com
Discover Art, P.O. Box 262424, San Diego, CA 92196

Copyright ©1989, 1994, 1995, 1998, 2000, 2002 by Sandra Angelo
First printing 1994
Second edition 1995, revised.
Third edition 1998, revised.
Fourth edition 2000, revised.
Fifth edition 2002, revised

1. Drawing 2. Art 3. Self Help 4. Art Therapy

Library of Congress Catalog Card No. 95-078792

ISBN 1-887823-34-4
UPC Code 600255-23-34-4

Printed in U.S. A. CIP 95-078792

Layout & Design by Ken Cook

Illustrated by:

**Sandra Angelo, Tiko Youngdale,
and Gré Hann.**

Contributing students:

**Orville Thompson (front cover), Marilee Johnson, Bob Estell,
Gordon Kleim, Fred DeGroot, Grace Igasaki, Nancy Kearin, Cheryl
McIver, Rose Marie Barr, Marion Clute, Barbara McVey, Nathan
Davies, Gre Hann, Tiko Youngdale, Kunda, Guido Da Pipe, Nita Draut
and Jeannine DeGroot.**

Design and Layout by:

Ken Cook

Call Toll Free:

1-888-327 9278

**DiscoverArtWithSandra.com
Discover Art, P.O. Box 262424, San Diego, CA 92196**

This book is dedicated to the memory of Virginia and Ernest McFall, whose amazing lives taught me by example that there wasn't anything I couldn't do if I had faith.

How To Use This Book

Begin at the beginning and work your way through the book sequentially. Read and follow all the instructions carefully. This is especially key for rank beginners. These methods have been tried and proven on thousands of students so you would do well to follow this sequence carefully. If you skip portions and jump all around, you may not improve as dramatically as the artists you see in the beginning of this book.

When you get to Chapter Seven, it is permissible to work out of sequence. Those drawings are presented in a loosely structured format, with the easiest subject first, gradually progressing toward the most difficult. While, it's always good idea to begin with easy objects and move toward the most challenging, by the time you reach this chapter, your skills may be strong enough that it wouldn't hurt to jump around a little. Generally, if you look at a drawing and think it's easy, it probably will be, especially if it's a subject you like.

Many folks are reading learners who can learn to draw by simply reading the book and practicing the exercises. Others are visual learners who need to watch the instructor's hand and see exactly how to shade. If you are having a problem with your shading techniques, you may want to purchase the four companion videos that demonstrate this book's lessons. *Drawing Basics* will walk you through the first half of the book and show you how to shade and more. *The Easy Way to Draw Landscapes, Flowers and Water* and *The Easy Way To Draw Animals* will demonstrate various drawings in this book. The video, *7 Common Drawing Mistakes and How to Correct Them*, illustrates the mistakes beginners encounter most frequently as well as the ways to correct them. (See order form in the back of the book.)

If you choose to use the videos, be sure to play them over and over again until you fully grasp the shading techniques. Some students have found they have to repeat the lesson several times, drawing along with the instructor, watching the demonstrations again and again before it finally sinks in.

Many folks ask me, 'How long will it take me to learn to draw?' My answer is, 'How many hours per day are you planning to practice?' There is no magic number of days for this process but as a general rule, students who draw for 45 minutes to one hour per day, usually finish the book in 60-90 days.

If you are looking for structure, set a goal of learning to draw in 90 days. Read chapters one through three in the first day or two. Then practice the exercises for about 45 minutes to an hour daily. Mark off your calendar with the number of drawings you have completed that day. For those of you who are on a busy schedule, you can always find at least 45 minutes each day to relax. If you have more than 45 minutes to devote to drawing, that's great. As you begin to improve, drawing will become a retreat where you can enjoy quiet serenity. You won't believe how much fun it is to draw. So turn the pages and let's get started!

Contents

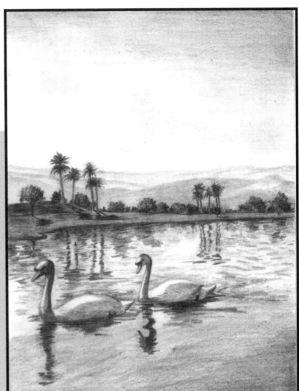

If your art work is so bad, it never even made it to your Mom's fridge, I have good news. on my website, **DiscoverArtWithSandra.com,** I have a gallery called 'Sandi's Fridge'. To get your work displayed and clear your besmirched reputation, simply follow this process.

BEFORE you begin this book, sit down with a mirror and draw your own face on an 8.5x11 sheet of paper. **LIMIT YOURSELF TO FIVE MINUTES. DON'T CHEAT!** Sign the drawing, scan it, date it and file it away. After you finish this book, take that first drawing and email it to me along with your most successful drawing. (75 DPI) If we post the before and after drawings, we'll send you an email that you can forward to all your scoffing friends and family with a subject line of *nyah, nyah, nyah, nyah, nyah nyah*.

Introduction

||

Transform your skills from amateur to artist in a few easy lessons ...

Didn't you just hate that kid who was over in the corner drawing super sonic jets when your airplane looked like a goose egg with webbed feet? Or that little girl with the blonde braids who drew horses from the Winner's Circle when your horse looked like a mutant rat on stilts?

Well, if your art never made it to the bulletin board at school and not even to your own mother's refrigerator, here's your chance to avenge yourself and clear your besmirched reputation. Forget losing 30 pounds, tummy tucks, hair implants, or face lifts. After completing the lessons in this book, you will be able to draw a perfect mask to wear to the upcoming high school reunion! You'll show them! No more irreverent snickers or giggles for you.

Now that I've promised you the ability to draw the perfect body, I really do need to insert a disclaimer. This foray into the world of art will not be unlike your first date. You will feel awkward at first, you will spill things, mess things up, you'll feel like a fool at times and wonder when it's going to be over. But like any good friendship, the more time you spend at it, the better it gets.

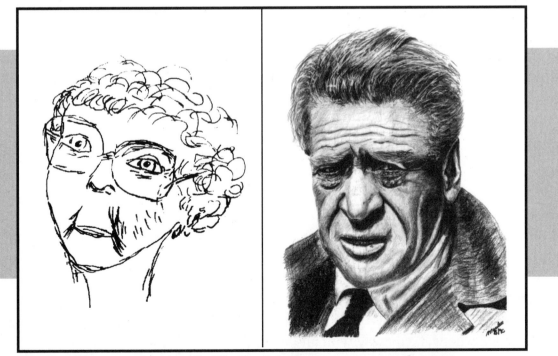

Fig. 1 — These two drawings by Marilee Johnson were seven weeks apart.

What makes you think I can do this?

You've always wanted to draw but you thought you had to be born with talent. I have fabulous news. It's not true! After working with thousands of people who can't draw a straight line, I have developed a sure fire four step method (described on page 43) that will take you from drawing like an amateur to drawing like an artist in a few easy lessons.

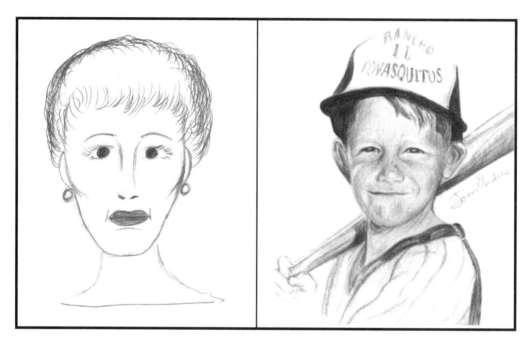

Figure 2— In eight weeks Joan Storms went from drawing with weak skills to rendering this superb drawing of her little grandson.

One of the biggest frustrations for rank beginners like yourself, has been the lack of simple books; art books which assume you know NOTHING. Instead of starting you in first grade, many skip straight to the tough stuff. At last, there is a book written just for you! I'll tell you everything! Which side of the paper to use, which end of the pencil to sharpen, which eraser is best for which pencil, etc. I assume nothing. If you are already past this stage, simply exclaim, 'Pshaw, I know that!' and move on.

This is the first art book designed for people who have no natural talent. It contains lots of information and data that I have gathered from many years of research while teaching people who showed up for class with no more than a desire to get revenge on that Esmerelda Fishback who walked away with all those art awards. I listened to these rank beginners as they watched me draw, and when they said things like,' Look she's pressing harder

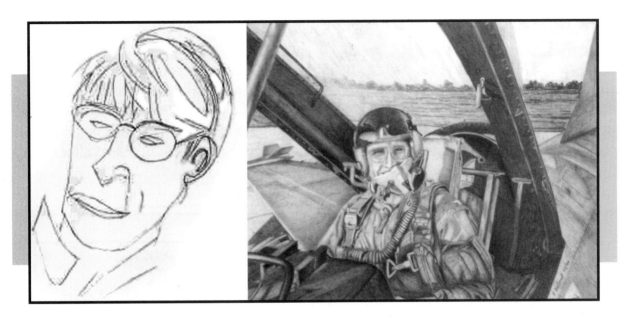

Fig. 3 — In 12 weeks, Fred progressed from drawing like an amateur to drawing complicated, sophisticated art. Even though this drawing was very involved, he found it relaxing because planes are his passion. You see, he was one of the engineers for the F16.

and she just turned her paper around,' the next time I taught , I said, 'Now you press harder and turn your page a little.' (Pretty smart eh?) So now you're the lucky beneficiary of their experience. They taught me what you need to know in order to learn to draw.

Com'on, have you seen me draw...?

More good news! Talent is REALLY not necessary. There are only four ingredients required for drawing success.

First, you must have a burning desire to learn. Whenever one tackles a completely new skill, they often feel intimidated by unfamiliar new terms and the awkwardness of their first steps. A fervent desire to draw, patience, & a willingness to make mistakes will help get you through the times when your flowers turn out looking like mutant potatoes.

Second, you must have fine motor skills and adequate eyesight. Any adult who can write their name has this. (More good news! If you can't draw a straight line, that's great! Most of the lines in art aren't straight. We artists leave straight lines to machines and rulers.)

Third, you must practice. As with any endeavor, practice makes perfect. There is a time meter connected to your hand. The more you draw, the more time you accumulate on the meter. After a certain amount of practice time, you automatically learn to draw.

There is actually a direct cause and effect relationship between practice and successful drawing.

And the last, and most important ingredient is persistence. The race goes not to the hare but the tortoise. Those who don't give up, succeed. You will be happy to know that in twenty years of teaching, I have never had a single student complete the course without learning to draw, no matter how weak their start. (Look at the before and after drawings in this book!)

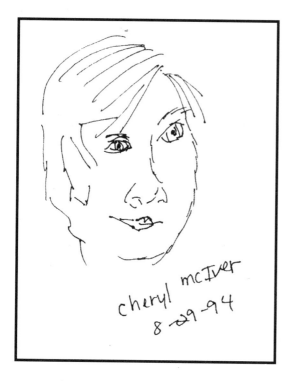

Fig. 4 — Look at the remarkable progress made by Cheryl McIver when she studied the masters' drawing techniques. These drawings were done five weeks apart.

Materials

||

Pencils

All the exercises in this book are done with a graphite drawing pencil. These pencils are available in varying degrees of hardness. The density of the pencil will determine how dark or light the mark will be, how smoothly the lead will lay down and how long your pencil will stay sharp. In the beginning I recommend that you draw strictly with graphite. It's enough to learn all the drawing techniques without having to figure out how to use different products. Once you master graphite, you can begin to explore other drawing media. In my book, *Exploring Colored Pencil*, I teach how to combine a variety of media. Trying various media is only fun after you know the basics of drawing.

The density chart below shows the varying degrees of hardness commonly available. Keep in mind that the performance of each pencil will vary greatly from brand to brand. The pencils I recommend on the order form in the back of this book are specifically selected to give you the maximum range of values (lights and darks). It really matters what brand you use. They are not all equal. All the enclosed exercises were done with my brand, so if you are not getting the same results I do, you may want to switch to my pencils.

Warning: If you use the wrong pencils, you can press down all day and your paper will get crushed but your values will never get darker. With a good quality pencil, you can get a very wide range of values. I have a philosophy that says, "Use junk, you get junk. Use good stuff, you blossom." Don't come whining to me if you use bad pencils.

Drafting Pencils								**Drawing Pencils**						
6 H	5H	4H	3H	2H	F	H	H B*	B	2B	3B	4B	5B	6B	

← Harder & Lighter	Softer & Darker →
On this side, the higher the number, the harder the lead will be and the lighter the mark. i.e. 6H will make a lighter mark than a 2H. Because these pencils have a hard lead they will stay sharp longer and give you more detail.The pencils on this side are mainly used for drafting,engineering, architectural rendering, and other work where there is a need for a sharp lead and fine detail.Although some artists use them, most primarily use the pencils on the other side.	As the numbers get higher on this side, the leads get softer and darker. i.e. You will achieve much darker marks with a 6B than a B. These pencils are excellent for soft shading but will dull quickly. Most artists limit themselves mainly to the pencils on this side. On rare occasions where they need light values, like blonde hair, they may venture over to the other side and grab an F.

Figure 5

*The HB is the lead generally used in the common yellow household pencil with that terra cotta eraser. While you can take great phone messages with this, it's pretty lousy for creating deep dark values or soft gradations. If you are a 'hatcher', (meaning you don't mind if your lines show), you might like the HB . If you are a 'graduator', and like soft changes in value, (with no lines showing), you will probably prefer using the B leads.

Because it may drive you to the loony bin if you try to memorize the density charts on page 5, and remember when to use which pencil, I have devised a somewhat idiot proof system for drawing with graphite. I took the three most commonly used densities and labeled them, light, medium and dark. For example, when you want to deface your boss's portrait with blackened teeth, you would use the dark pencil. When you want to draw your Uncle Floyd's silver hair, you would use the light pencil.

Later, in the chapter on shading, you will learn how to create a full range of light and dark values by using only one pencil density. Although I personally don't switch pencils very often, when I want to enhance a dark area I use a 6B. If I want to get a delicate, light stroke I grab an F pencil from the left side of the chart.

I'm not sure how or why the F wandered onto the left side, but somehow it did. (Who knows, maybe Mr. Chartmaker was a bit inebriated that evening, or maybe his wife Myrtle changed it in the middle of the night to sabotage him for not picking up his underwear, or maybe his first name was Floyd and he wanted to name a density after himself, or maybe... woops, we're digressing.) Anyway, in my opinion, the 'F's' texture is more suited to the B side of the chart, but then I wasn't around when this chart was invented, so there was no one to set them straight.

T I P

Keep in mind, the best way to make lights look really light, is to place strong darks behind them. So, when you are drawing a blonde, you would often use the medium and dark pencil in the shadow areas so as to emphasize the strong light highlights. Even if you just paid $100 to get rid of those dark roots, you must place strong shadows at the roots so as to anchor the hair to the head. Remember, just because a subject is light, doesn't mean you only use light pencils. Even light subjects have medium and dark shadows.

One More Tip: In my opinion, (which is usually right), the H pencils don't mix well with the B's unless you have a high quality brand. The texture of the two pencils can be quite different, preventing them from blending. The only time I pick up the lighter leads is when I want to get a really delicate value like the texture of blond or gray hair or a baby's soft skin. If you are using a good brand, the lower number H pencils like H, 2H, 3H and the F will create very light values. With an inferior brand, the H pencils simply indent your paper.

GETTING ACQUAINTED WITH YOUR PENCILS...

Whenever you try out a new tool, it is best to test it and see how it works. Most realists hold their pencil like they would hold a pen. When they draw, they use tight, controlled strokes, drawing with their fingers. This allows them more command over their marks. Artists who do impressionistic, (or abbreviated) renderings like to grasp their pencil like they would a brush. They use arm movements, holding their pencil at a distance, making loose, casual strokes. You might want to try both methods to see which feels most comfortable to you. You may even find that you like to mix it up, drawing the landscape loose, then detailing the goose bumps on a plucked chicken with tight, controlled strokes.

In this book, I have both realistic and impressionistic drawings. My drawings tend to be very exact and delicate. Don't be concerned if your style is not like mine. Look at Figures 8 - 10. We all drew the same subject, yet each person's style was unique and differ-

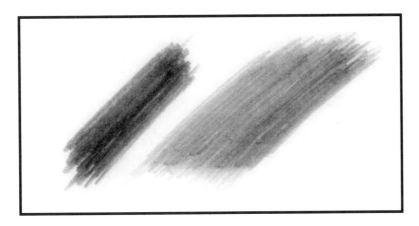

Figure 6: Here is a sample of the texture created by using an H pencil. On the left is a swatch drawn with a 2B. In my view, these two textures don't mix properly.

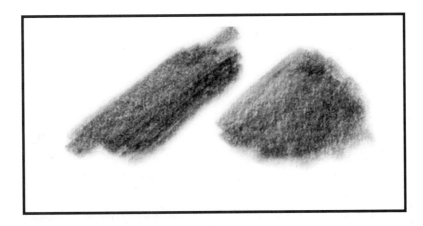

Figure 7: Here is a swatch drawn with an F pencil. I have blended it into a 2B. In my view, these two pencils' textures look more compatible.

ent. Each of you will have a slightly different style. Just as it is with handwriting, everyone is unique, so, don't be concerned if your drawings don't match the ones in this book exactly.

Figures 8-10: Each of us drew the same subject, but our strokes were unique, making every drawing a different and distinctive style.

Figure 8

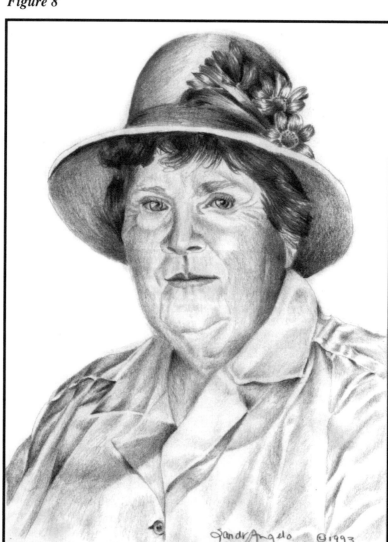

Drawing by Sandra Angelo

Figure 9

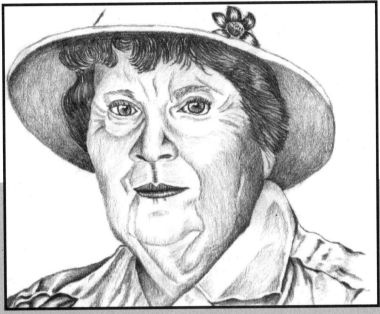

Drawing by Grace Igasaki.

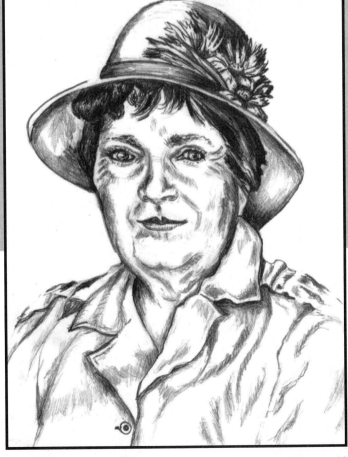

Drawing by Nancy Kearin

Figure 10

Paper

There are a wide variety of papers available on the market, most of which are bound in sketchpads. The quality varies dramatically and, unlike pencils, quality does not always correlate with price. Some excellent papers are very reasonably priced while some terrible papers are the same price as the good ones. Shopping for a good paper can be quite confusing. Almost every tablet will say its suitable for drawing, even if it isn't, so I made life simple for you.

Good news... your sketch pad is bound into this book. To save you the trouble of guessing which brands would work for these exercises, I bound good quality paper into this book so that you can use it as a workbook and sketch book. If you run out of paper, you can use the order form in the back of this book to send for my special sketch pads. In addition, most of the exercises I recommend require gridded paper so I made it easy for you by drawing the grids right on the practice paper in your book.

Caution! Soap box ahead. (This is where I get up on my podium and lecture about the importance of using good supplies 'cause I don't want to hear your whining when you get bad results using crummy stuff.) I recommend that you do all your exercises right on the paper in this book. Some people, who want to conserve their paper, will try to draw these exercises in other sketch books. This will defeat the whole purpose of why this book was created. I carefully selected the correct paper for you. If you choose your own paper, you might select lousy paper, 'cause you don't know how to choose a paper. Then you'll get bad results.

T I P

When you draw with the graphite pencil, your paper needs a 'tooth' or 'bite' to it. This means it needs to have a slightly rough texture so that the graphite will chip off and become deposited into the microscopic grooves of the paper. (To understand this better, remember when you tried to use a pencil to write a mushy poem to your favorite beau on the back of a slick greeting card? The pencil wouldn't stick because the paper was too slick(or maybe your verbage was too mushy). That surface is considered a plate finish and it has no 'tooth'. (Graphite pencils will only adhere to a paper with 'tooth'.)

Things that can go wrong...

You cannot get a full range of values with bad paper and, flimsy paper will pill (like a sweater) when you erase it. If you try to draw on a section you have erased, the graphite won't stick to your paper.

In addition, low quality paper will yellow and slowly deteriorate (Remember what happened last time you left the morning paper on the door step all day. The paper became discol-

ored.) You may want to frame a drawing, or at least save it. If you have paper that is disintegrating, you can't perserve it.

So to save you from your own well meaning frugality with its corresponding failure, I paid big bucks to bind good paper into this book. So use it already!

I have seen so many beginners waste time by using bad paper and cheap pencils. They are not doing the drawings wrong, it's just that they can't get the correct results with bad paper. Nag, nag, nag. I admit it. I have a fetish about using the right supplies. I get tired of the grumbling when people moan to me about their bad results, and it's all because they've used the wrong supplies. So, indulge yourself. Use good materials. (Honestly, the good paper costs exactly the same as the bad stuff. And if you use good quality, you'll save money in the long run 'cause you won't need nearly as much Maalox®.) Okay, okay, I'm climbing down off my soap box now.

ACCESSORIES

Dust Brush
Because graphite can get messy, you will need to purchase a dust brush to rid your paper of graphite residue and eraser crumbs. In my studio, I use a large drafting brush but on the road, I like to take along a goat hair brush. It's the perfect size and is nice and soft. (I prefer natural hair brushes over synthetic because they are gentle on the paper.)

If you can't find a goat hair brush, you can buy one using the form in the back of the book. Or you can visit Old Mac Donald and borrow one of his trained goats who will swish his tail over your paper on command. (Be careful to use the correct end of the goat. If the goat's head faces your paper, he will eat it, unless it's crummy paper; in which case, you'll wish he would eat it.)

Erasers
An inexpensive art gum eraser will work well to rid your paper of most mistakes. Although this eraser will crumble and smudge the graphite a little, it is the best at lifting large errors.

If you make a section a little too dark, you can gently lighten the area by pressing a

> **TIP**
> To keep your drawing free of smudges, use a piece of clean paper underneath your drawing hand. This will prevent your hand from picking up graphite and dragging it across your paper. I find that an 8x10 glossy photo with the shiny side down is the most effective shield because the slick paper will not absorb graphite.

kneaded eraser against that object. The kneaded eraser will stick to the paper and lift the dark values, leaving a gentle, soft gradation behind. (Other erasers leave an abrupt edge when they erase.)

My absolute favorite eraser is the small hand held, battery operated eraser because you can actually draw with it. It glides over the surface of the paper lifting the graphite rather than grinding it into the paper and crushing the tooth. To see how it works, look at Figure 11. I drew some grass and lifted out the highlights with my battery operated eraser. (As an aside, this eraser works well with other drawing media including colored pencils. About the only thing it won't erase is cellulite and wrinkles. Believe me, I've tried.) **Caution**: Beware of cheap battery operated erasers. They work fine till they hit the paper, then they stop. The best brand is on our order form in the back of the book.

There are other erasers out there, like pink erasers, plastic erasers and such but in my view these smudge too much. They skid in the graphite and create a little slurry which is very difficult to remove. Therefore, I limit myself to the erasers described above.

Figure 11

Pencil Cases
Believe it or not, pencils are fragile. The graphite leads inside the wooden casing will break if you drop your pencils on the floor. Then when you sharpen your pencil, the lead will break off into your sharpener. To prevent this, I carry my pencils and erasers around in a neat little case. (All artists with any fashion sense, have a different case for every outfit.)

Fixative
When you are absolutely sure that your drawing is perfect and you never ever want to change it, (i.e. if the Louvre just offered you $30 million for it), you can spray the draw-

Don't be confused by the term workable... that only means that you can draw on top of the fixative. Whatever is underneath the workable fixative is there to stay.

ing with fixative to seal it and prevent it from smudging. I always use workable fixative because I'm never really sure my client will like it that I drew all four of her chins. If I already sprayed the drawing with workable fixative, I can't remove one of the chins, but, I can add graphite pencil on top of workable fixative. So, I could change one of her chins into a turtleneck sweater. (If I had used a matte or glossy fixative, I could not add pencil because the surface would be too slick.)

Caution: Remember that fixative is very toxic. Whenever I spray it, I go outside and lay a weight on each corner of my paper. Holding the can 12-18 inches from the drawing, I lightly coat the paper using horizontal strokes. It is better to give the drawing several light coats, rather than one heavy one. A heavy application will cause the fixative to run.

Because I want to live a long time with my brain intact, I also take precautions so that I won't breathe the fixative. I wear a painter's mask from the hardware store while I am spraying and I close the windows and doors next to that spot. It only takes a few minutes for the fixative to dry but the odor lingers, so I set a timer and leave my drawing outside for 15-20 minutes. (The timer will remind you to retrieve the drawing before the scouts from the Louvre sneak up and steal it.)

Sharpeners

I use three different tools for sharpening. In my studio I use a vertical electric sharpener. For the road, I take along a battery operated sharpener and, to liven up a dull point between sharpening, I keep a piece of sandpaper close by. **Caution**: Avoid the cheap battery operated sharpeners which have simply taken a hand held sharpener and mounted it to a motor. Before you buy a sharpener, remove the casing where the shavings will be stored and look at the blades.

Be careful when you carry your battery operated sharpener around with you. If the casing for the shavings is not well attached, it may come off in your bag and leave a big mess. This problem can often be solved by simply wrapping a large rubber band around the sharpener to secure the casing.

CHAPTER ONE

INSTRUCTIONS FOR GETTING STARTED *So where do I begin...?*

A Drawing System For The Artistically Challenged (Notice we didn't say klutz.)

There are many effective ways to learn to draw. Those ways have already been described in other art books. If they had worked for you, you wouldn't be reading this. So, what makes this system different?

Well, believe it or not, I actually started out teaching in high schools, ivy league prep

Fig. 12

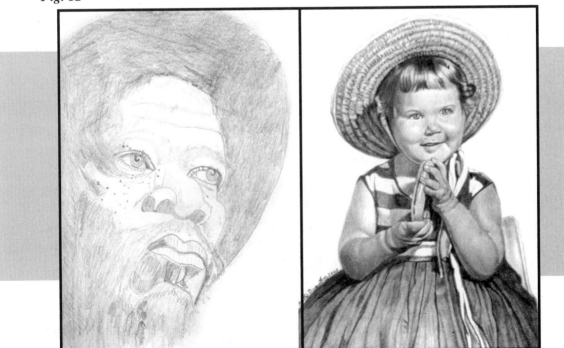

Fig. 12 - Look at the dramatic improvement that was made by Nita Draut.

schools and universities. I was teaching a traditional art curriculum to naturally gifted students and my drawing lessons were so effective that I was even selected as one of the nation's top art educators for a Fellowship Award from Rhode Island School of Design. So I thought I could teach anybody. Wrong!

Much to my surprise, when I moved into adult education classes and found a room full of wanna be artists with no real talent, my tried and true, blue ribbon, award winning, traditional drawing lessons didn't cut it. No one understood a thing I said. I discovered that these folks learn in a radically different way. For one thing, they didn't even understand the language of art. Next, they were not inclined to deduce things on their own, they needed to be guided, and shown, step-by-step, with very specific instructions, until they eventually felt comfortable enough to venture forth on their own. So I threw out all of my prized techniques and started from scratch.

In this book I am presenting the results of a proven system that has worked for thousands of people just like you. I learned how to teach these new artists by listening. I listened to them describe the drawing process in their terms and I began to repeat it back. Over a period of years, I perfected this system by watching them and seeing what was effective and what wasn't.

That means there's more good news!

You are not a guinea pig! Many lab rats have paved your way so that you don't have to suffer.

Realize that everything will be presented in a step-by-step format, with a full explanation of the tools you will need and how to use them. While the world will not come to an end if you use the wrong pencil, you will probably get different results with other types of pencils. The whole system is predicated on the assumption that, if these exact methods and tools worked for thousands of others, they will work for you too.

The reason I tell you exactly what to use is because my rank beginners have begged for that format. To those of you who may have one recessive artistic gene, you may feel beginning twinges of rebellion when I tell you exactly what to do. To you, I say, 'If you are getting equal or better results doing it a different way, go for it'. The rest of you really

should follow this book step-by-step in the exact sequence presented, using the same pencils and papers I describe, or else you won't get the dramatic improvement most of my students have experienced. For those who are not naturally artistic, it's usually best to stick to the lesson until you know the rules well enough to break them. (Most good art is made by breaking rules but only by people who learned the rules first.)

Tell your friends emphatically... 'No snickering, unwelcome advice, or disrespect.'

You are embarking on a private journey. No one invites people to listen to them practice the piano, or football, or the violin. Don't let people watch you practice. Your sketch book is private, off limits.

'Why?' you ask.

Everyone is an art critic. Very few people in America, except the very talented, have taken art in school, but that doesn't keep them from being a 'know it all'. They often come up with very thoughtless comments that may sting, wound and discourage you, and all along they were just 'kidding' or 'trying to help'. The rank beginner has a very fragile ego. Most beginners don't really believe they can learn to draw in the first place and all it takes is a few of those snide comments to conjure up humiliating memories of art class.

This sketch book is your practice field. If you think someone is going to be critiquing your work, you will be more hesitant to relax and make mistakes. This mind set will keep you out of the creative right side of your brain. So keep this sketch book to yourself. Later, after you've finished this course, you can show everyone your finished pieces... but only show your best work. Believe me, you don't want to hear about the rest!

THE MAGIC DRAWING SYSTEM ...

Most traditional art teachers set up a still life or a model in the middle of the room and say, 'Draw'. New artists don't have a clue where to begin. 'Where do I start ... with the eye, the elbow, the ear...? How do I make a three dimensional object on a two dimensional piece of paper? What type of stroke do I use to draw hair? '

To beginners, drawing from live models feels like starting school in 12th grade. Since I believe it's too difficult for a rank beginner to draw objects from real life, I am going to take you back to the easiest form of drawing and present you with a graduated level of difficulty.

• Level One - Copying the Masters

"Stop right there!" you say. "It's cheating to copy." Well, guess what? Everybody's cheating then. Golfers copy Tiger Woods. Pianists copy Van Cliburn. In the Degas wing of the Norton Simon Art Museum, there is a Poussin painting, copied by Degas. If that's the way all the masters did it, guess what? It's legit.

Copying is the easiest form of drawing. It's easy because the drawing is already two dimensional. The artist has already solved the drawing equation, determining the texture of the strokes, the darkness and lightness of the marks, and the direction of the lines. All you have to do is copy.

What do you gain by copying? First, every time you draw, you are developing hand eye coordination. Next, you learn how to create textures, how to shade, how to draw eyes, how to simplify millions of tiny hairs to suggest the style rather than detailing every hair, etc. As with the art of calligraphy, as you copy, you improve your strokes. (Don't be worried about losing your own creative style just because you're copying. Copying good penmanship never made anyone lose their own handwriting. It simply improves your technique.)

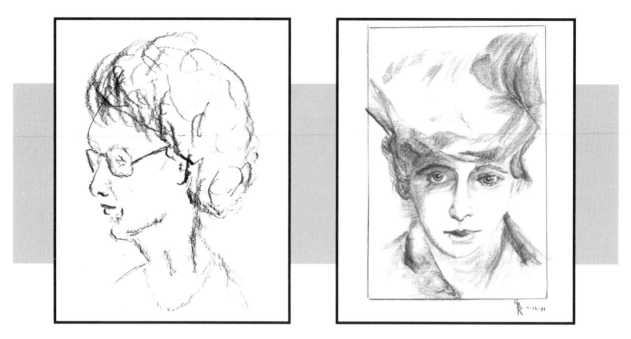

Figure 13: In just five weeks, Gordon Kleim improved his drawing skills dramatically by copying the drawings of the masters.

When do I stop copying?

I recommend that beginners copy the masters until about 80 % of their drawings are turning out well. (Like high jumping, you don't raise the bar till you've been clearing it frequently.) Success breeds success. Stay with the easy things till you get good at them. The confidence you build, will help you gain courage to try the next level. Beginners need a lot of success to keep motivated. If you try things which are too difficult, you will experience a lot of failure. Repeated failure makes most people discouraged and then they give up. Wait till you are succeeding regularly before moving on to Level Two.

• Level Two - Copying From Photographs

Ah ha! Cheating again. Among the myths that surround art, is the belief that it is more noble and pure to draw from real life than to copy from a photo. Why? Because that's the way the masters did it! Do you know why the masters didn't use photos? Because they hadn't been invented!

Since the public expects artists to draw from life, many modern artists try to hide the fact that they use photos. I once read a book where an animal artist was actually claiming he never uses photos, yet his paintings had subjects like a lion leaping through a flying

cloud of dust, chasing a terrified zebra. Right. And I have some great swamp land in Florida.

Photos are fabulous for artists because they trap light, action, a glance, an innuendo, a frisky kid and other stuff that just moves too much. While artists are not slaves to photos, most use a combination of photos and live objects. Photos are a modern tool, so use them. Nobel prize winners use computers, even though the masters used a quill dipped in an ink well. 'The times they are a changin'.

Why is it easy to draw from a photo? Because it is already two dimensional. And, black

Photo by Sandra Angelo

Fig. 14 & 15 —Drawing from photos is easier than drawing from real life because the object has already been reduced to two dimensions and the values are clear, (meaning it is easy to see the light and dark patterns). Drawing by Gré Hann.

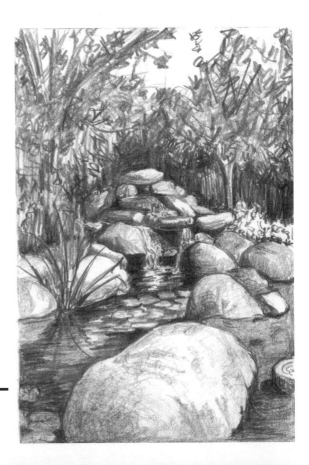

and white photos have already solved the value (that means light and dark) equation, and they can be gridded. (Grids will be explained later on page 44.)

So, once you've graduated from copying masters, begin working from black and white photos. Here, for the first time, you will have to solve the drawing problem. You must decide what kind of strokes to use for the hair, what direction your lines should take when drawing a nose... etc.. I will guide you through this and you will draw on the techniques you learned from copying the masters. After you've reached the 80% success level copying from photos, move on to level three, copying from real life.

• Level Three - Copying from real life.

Now you are ready for the level where most art classes begin, drawing from life. This is hard. Not only do you have to determine the direction of your strokes, but now you must learn how to translate color into black and white, and how to draw a three dimensional object on a two dimensional surface without making it look flat. This will probably be your most difficult transition. However, your practice will have taught you hand eye coordination, how to measure proportions, how to shade and how to create texture. Don't be surprised if it takes a little longer to master this level of drawing.

Fig. 16 — When you begin to draw from live objects start out with simple shapes and as your skills improve, increase the level of difficulty.

• Level Four - Composing original, creative art.

A lot of people think that all artists can draw anything out of their head. Surprise! It's not true. In teaching literally thousands of talented, creative, non-talented, and other assorted species, I have discovered that only 5% of talented artists can draw from their imagination. All others use live models, photos or a combination of the two. So if you can't draw out of your head, join the 95% ranks. (Many artists who can draw out of their heads are cartoonists.)

But, even if you can't create imaginary objects and fantastical beasts, after you master your drawing skills and study a variety of media, you will be able to compose original drawings. You will learn how to combine a series of photos with everyday objects, change things around and mix them up until you have an original piece of art which expresses your thoughts and feelings. (You can learn all about that in my next book, *Exploring Colored Pencil*. In that textbook I've written two chapters called *Design Techniques and The Creative Process*. Those chapters will walk you through the creative process and teach you how to tap your creative skills.

You've either got it or you don't...

To that, I say 'Balderdash!' That's silly. If you picked up a violin, and dragged the bow across the strings and then recoiled from the discordant sound, you would say, 'Naturally I sound bad, I've never learned to play'. But if your first marks with a pencil aren't brilliant, you don't say, 'I haven't developed the skills for expressing myself', you say, 'I can't draw'.

All you really need to be a creative artist is to learn the rules first. As with writing, you learn grammar, syntax, punctuation, spelling and such before you take a creative writing class. You can't write creatively if you don't know the rules. No one would understand you if you couldn't spell and punctuate. So it is with drawing. You must learn the basics before you can express yourself effectively. The lessons in this book will teach you the language of art. This book is like a preschool. Once you've mastered these concepts, you will fit comfortably in any traditional art classroom because you will now understand the language!

You are in for an exhilarating surprise! Learning to draw will liberate your creative mind and provide you with the skills you have wanted so badly, the skill to express yourself visually, whether you want to draw a picture of your boss's face on your dart board, draw yourself with thin thighs and two less chins, or immortalize the world's cutest grand kids for posterity.

So enough hoopla already, let's turn the pages and get started drawing!

*Fig. 17 — **Practical uses for your new drawing skills... Immortalize your grandkids.***

CHAPTER TWO

LEARNING TOOLS

DRAWING WITH A GRID

Artists see the world differently than you do. The key to drawing like an artist is beginning to see the world as they do. They see objects in terms of five key elements: shape, line, value, texture and color. In the following lessons, you will complete exercises which deal with the first four elements. (Color theory is so involved it will require a whole different book.) The lessons in this book will center around the four elements of shape, line, value and texture.

Learn to see shapes.

Artists see objects as a collection of shapes. When a subject is viewed as a series of interlocking jigsaw puzzle pieces, it becomes easier to draw. For example, on page 27, notice that it is much easier to see the shape between the body of the girl and the arm, because it is enclosed. The shape outside the elbow is harder to see because it isn't framed by any lines.

Looking at the background will cause you to draw more accurately. If you look at the subject itself, you tend to glance at it and then look down at your paper for several minutes, drawing from your stored memory about the object rather than drawing what you actually see. When you look at the background space instead, you have to stare at it closely, because the shapes are more nebulous and you can't remember them long enough to draw from memory. Drawing negative space forces you to really pay attention, instead of drawing from memory.

Look at Figure 18. The cement truck is driving away, making this a difficult, foreshortened view. However, when horizontal and vertical lines are placed next to the edges of the truck,

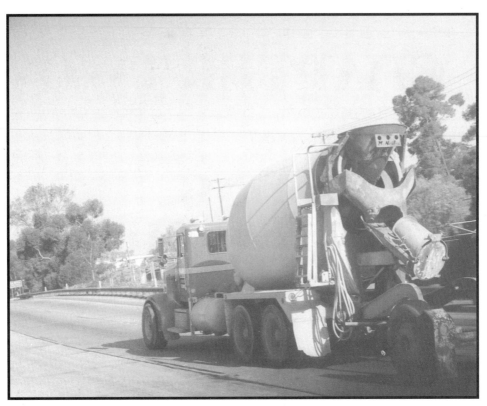

Figure 18 — Guido Da Pipe's Cement Truck might be hard to draw because it is a foreshortened view.

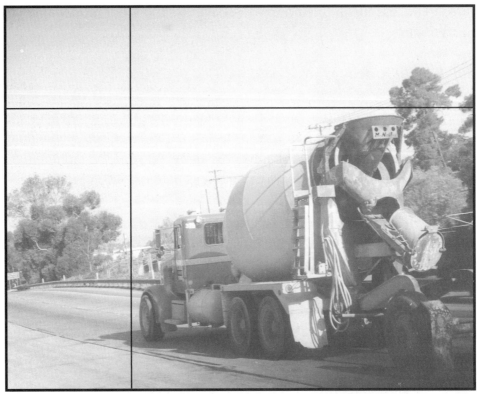

Figure 19 —Here you see a horizontal line above the truck and a vertical line in front of it. When you place a horizontal or vertical line next to the object, it traps the negative space behind the subject, making it easier to draw.

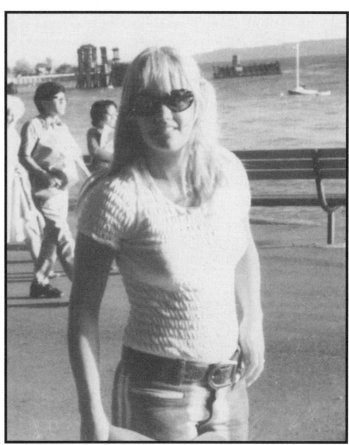

Figure 20 — To draw the arm on the left side of this photo, simply draw the space between the body and the arm and the space outside the elbow. As you can see, it's much harder to visualize the space outside the elbow because it's not enclosed. That's why we use the grid, because lines superimposed onto a photo break the subject up into shapes. Wish I still had THIS shape... I was 21 ... (this shape and my current brain). Yes, that's me, Sandi when I was attending college in Seattle.

(Fig. 19), the lines trap and enclose the negative space. If you simply draw the shapes behind the truck, you will have the position correct. If you learn to draw objects by viewing them as a collection of jigsaw puzzle pieces, you will be more likely to draw accurately.

Using The Grid...

Many artists use a grid of vertical and horizontal lines superimposed over their photo reference in order to see shapes precisely. This helps you to see the shapes more accurately. A grid is simply a collection of vertical and horizontal lines. As we relate each shape to its adjacent vertical or horizontal line, we will find it easier to draw.

Okay here we go again. All of you skeptics are chanting,

'Isn't it cheating to use a grid?'

Time to burst another myth. The masters of old used grids. Look at the two drawings in Figures 21 & 22. One is by Leonardo Da Vinci and one is by Edgar Degas. Even

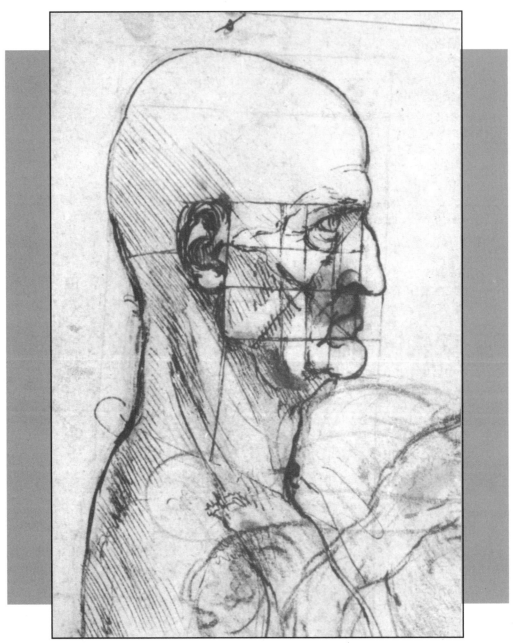

Fig.21

Figs. 21 & 22 — Look at these drawings done by the great masters. Leonardo Da Vinci, and Edgar Degas used a grid. If it's good enough for Ed and Leo, it's good enough for you.

Fig. 22

Michelangelo used a grid for the Sistine Chapel. If using a grid was good enough for Ed, Mike, and Leo, shouldn't it be good enough for you?

Three reasons to use a grid...

First, as we stated before, placing a vertical or horizontal line next to our subject will help trap the negative space and allow us to view it more accurately. Second, the grid helps us with proportions. In Figure 23, notice that the man's right eye is lower than the left one. In Figure 24, we have inserted a horizontal line to help us to see that the eyes are at different tangents. Without this line, we would probably look at the man and say to ourselves, 'Self, the man has eyes. Eyes are directly across from each other.' Then we would proceed to draw eyes like the man in Figure 25, wondering all along why he looks so weird. Using grid lines as a reference, we are more likely to place things accurately.

The third use for grids is enlargements. Michelangelo used a grid to enlarge his paint-

Figure 23 — Notice that the eye on the right side of the drawing is higher than the left.

Figure 24 — When we place a horizontal line at eye level, it becomes more evident that the eyes are at different heights.

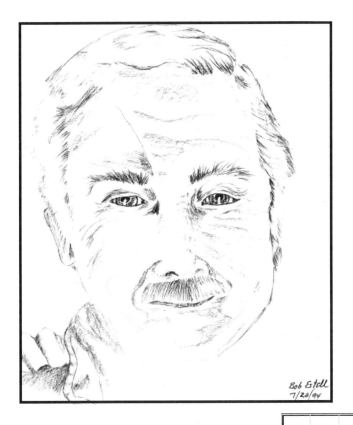

Figure 25 —If we glanced at the man, and then relied on our stored memory about eyes, we would tend to draw them both at the same level, even though that's not the way they really are. This student, Bob Estell, first drew the man without a grid. He was operating on stored memory that eyes should be at the same level so that is the way he inaccurately drew them.

Figure 26— When he redrew the man using a grid, he realized that the man's head is tilted, making one eye lower than the other. By following the grid, he was able to place the eyes more accurately.

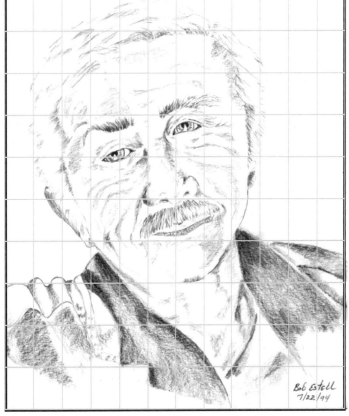

ing studies for the Sistine Chapel. When you are painting a ceiling, you can't back up to gain perspective. He had to break the subjects into a collection of modules so that he could retain the accuracy of his paintings.

How do I use a grid?

Because all of the practice pages in this book are gridded, you won't need to buy or make a grid kit to complete your lessons. However, after you've finished this book, you may find you need to continue using a grid for awhile. If so, here are the instructions for making a grid.

Option One: Draw lines on your drawing paper with a ruler and a light pencil. Make sure the boxes are always square. Rectangles don't work... (don't ask me why, this is not a geometry class now is it?) With the thin end of a black Identipen draw lines on top of your photo reference and label the grid boxes the same on both your paper and your picture.

Option Two: If you are too lazy to make your own, buy our grid kit listed in the back of the book. It has three acetate sheets with different size grids and grid paper to match. Paper clip the acetate over your photo reference, creating an instant grid. (This also prevents you from having to damage the photo by drawing lines on it.) Lay your grid sheet underneath your sketch paper and paper clip it in place. If you are using our sketch pad, you should be able to see the grid lines through the drawing paper.

How do I know what size grid to use?

Most people can get by with just a few sizes of grids. A one inch grid and a one half inch grid should suffice for most drawings in this book.

The grid size will be determined by the size of the object you are copying. In Figure 27 you can see that a one inch grid is perfect. In Figure 28 a one half inch grid was needed because of the size and complexity of the subject.

Note that you can also use a large grid for the majority of the subject and then subdivide the areas which have more complex details. See Figure 29.

Identifying Tangents

Many students find it useful to place a series of letters across the top and bottom of their grid, and a series of numbers along both sides of the grid. This will help you identify which square you are drawing; i.e. 'B 2' in Figure 27.

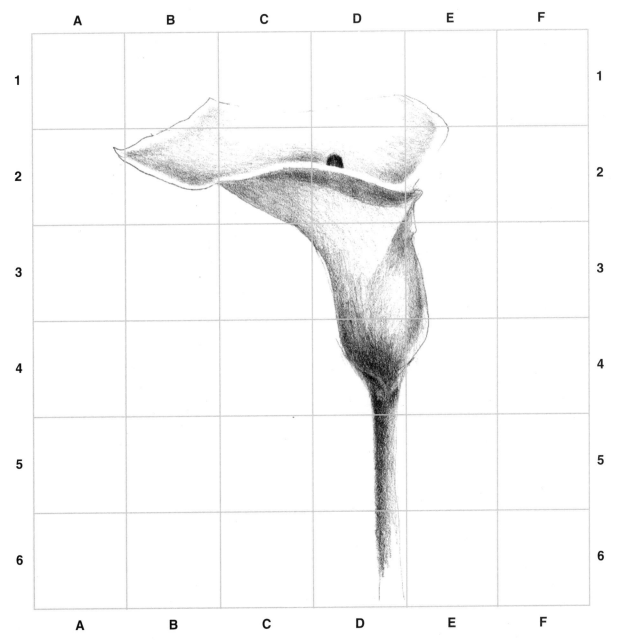

Figure 27—You can see that a one inch grid is appropriate for this drawing.

Drawing by Sandra Angelo

Aaargh! Will I ever outgrow the grid?

Yes. Calm down. Put the sedatives away. You will outgrow this stage. When you were first learning how to ride a bike, you needed training wheels until you learned to keep your balance. A grid is like training wheels. You need vertical and horizontal lines on your page until you begin to see the shapes without them. Eventually you will see objects as a collection of shapes. At that point, you will know you've outgrown the grid.

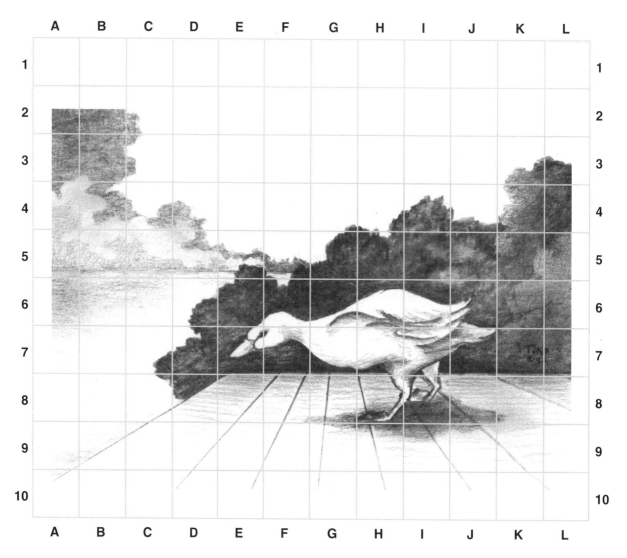

Figure 28 Because of the complexity of the details, a smaller 1/2 inch grid was used over this photo. Drawing by Tiko Youngdale.

However, you will still revert to using an occasional vertical or horizontal line here and there when you are trying to conquer problem areas. That's why Leonardo Da Vinci slapped a grid on the nose. (See Figure 21 on page 28) The face was a piece of cake but that snout was a real bear. The grid helped him resolve the problem.

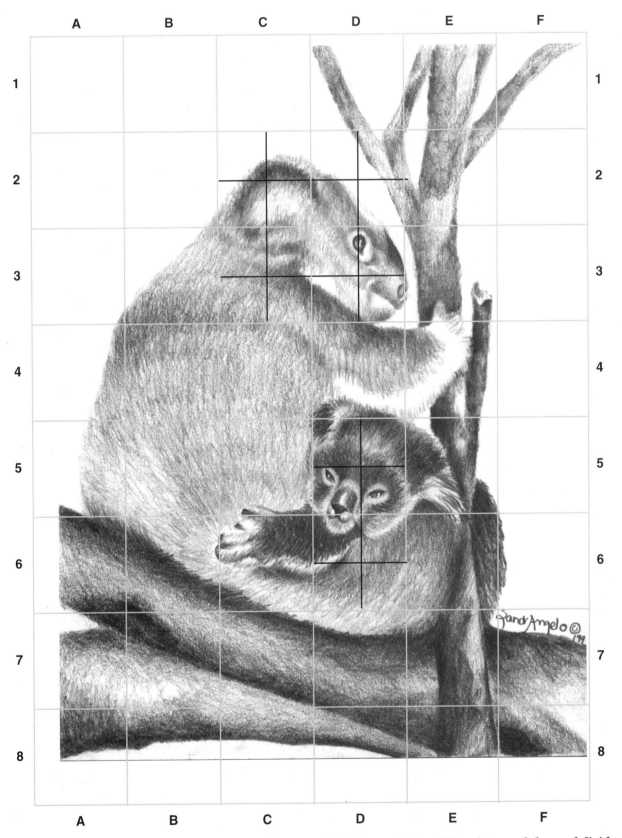

Figure 29— In some cases, you may use a larger grid for the majority of the photo and then subdivide the areas which have more complex details.

NEGATIVE SPACE DRAWING

CHAPTER THREE

SEEING SHAPES

You will be surprised at how much easier it is to draw things accurately when you begin by drawing just the silhouette while looking at the negative space behind the object. Because our brain stores preconceived notions about objects, we tend to rely on our memory about how these objects should look rather than paying close attention to the angle or perspective in front of us. For example, our brain stores the eye as an oval with a circle in the middle like Figure 30. Look at the eyes in Figure 31 and 32. You can't see the full circle can you? Notice that the three shapes in the eye in Figure 31 are very different than the three shapes in Figure 32. If you drew these eyes by looking at shapes, instead of drawing what you remember about eyes, you would draw more accurately.

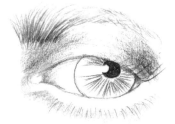

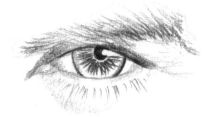

Figure 30—This is the way we think of an eye; an oval shape with a full circle in the middle. If you look at the eyes in Figure 31 and 32, you will see that you cannot see the full circle of the iris. Looking at the eye as a collection of shapes will help you see it more accurately.

Figure 31—Look at the three shapes contained within this eye. The white of the eye on the left is so much bigger than the white space on the right. If you drew these two white shapes and the iris, you would have an accurate eye.

Figure 32—Notice how different the white shapes are in this eye when compared to the shapes in Figure 30.

Drawing negative space is especially helpful when we are trying to draw objects which are foreshortened. Foreshortening means that an object is pointing straight at us. Look at the rhino in Figure 33. His body is coming straight at us. His head, which is in profile, would be easy to draw, but the rump, which is foreshortened, is tough. If we focused on his body while drawing, we would have a terrible time drawing him accurately. However, if we concentrate on the shapes around him (the negative space), as we did in Figure 34, we would be much more inclined towards accuracy.

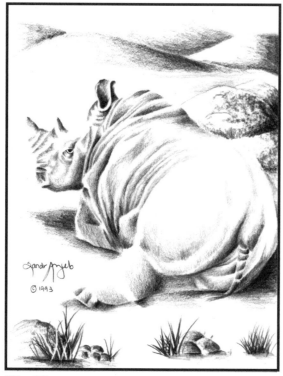

Fig. 33

Fig. 34

Instructions For Exercises

We learn to draw the Old Fashioned Way, *we practice*.

Here's a list of general instructions for all the exercises in this book.

One: In Chapters 3 and 4 I've provided a space to try the drawing with the grid and without the grid. Do both drawings. If your drawings are consistently accurate when you don't use the grid, you may not need it. If you don't need the grid, copy the drawings from this book in a sketch pad, (because sketch pages would not be gridded). Most of you however, are rank beginners and will need a grid. You should practice all of your drawings on the gridded paper provided in this book.

Two: We learn to draw the old fashioned way, we practice. If you want to redo any of the drawings, you can use a grid kit and practice the same piece over and over again in your sketchbook, until you are satisfied with the results. While it is very useful to practice the same piece twice or even three times, it's a good idea to complete most of the drawings in the book before going on to repeat them. Don't expect perfection. You are like a first grader ... very new at this. As you continue practicing, your skills will improve automatically.

It's not a good idea to do a lot of erasing. Just draw each subject to the best of your ability and turn the page and draw the next one. You'll be very surprised that some of your drawings will turn out well and others may be a tad worse. You'll find that when you are drawing a subject that you like, you will draw it well, even if it's difficult. Consequently, it's a good idea to start with drawings that look easy and fun. Once you meet with success, you'll have the courage to tackle more difficult subjects.

Three: The tortoise and the hare... remember who won? Take your time with the exercises. Don't compare yourself to others. There is no correlation between speed and talent. New artists who will end up becoming Impressionists generally work faster and those who will be Realists generally work slower. Work at your own speed and don't be pressured to keep up with others. It's better to take your time and make sure you master each concept before moving on.

Four. What does chocolate ice cream have to do with this?

You need to keep a visual record of your progress so that you can see how you are improving. Your drawing will improve very slowly, but just like gaining weight, you will not notice gradual changes. I have this on good authority because I've done the research. I ate just one bowl of Godiva Belgian Dark Chocolate ice cream every day for three months. I really couldn't see the difference until I looked back at a picture of myself in the beginning stages of my research. My figure had definitely changed. Your work will

change too, but the improvement will be very gradual. If you keep each drawing, you will be able to see your progress. Looking back at your early drawings will encourage you.

So, when you make a mistake, try to resist the urge to rip, slash or tear your drawing out of your book and feed it to your ravenous paper shredder. I know it will be difficult, but, if you exercise some restraint, you will be gratified by a visual version of your progress. For example, by the time you get to Chapter Six, you may not feel like you have made any improvement, yet when you look back at the drawings in lesson one and two, you will be amazed at your progress.

In addition, you will often learn a lot from reviewing your first drawings. As you progress, looking back at your old drawings will help you see the importance of using the new principles you have just learned.

Five: As a general rule, it is easier for beginners if the drawing process is broken down into simple steps like the drawings in Figure 35 on page 41. Many beginners find it useful to follow a four step process.

First, begin each drawing by putting in the negative space. Then, inside the same negative space, do a line drawing, which will serve as road map for your shapes and shadows. Next, shade the object to establish the light and dark values and finally, on top of this, place the textures or details. In this revised edition, I have provided negative space and line drawings of many of the exercises.

Six: Some people learn by reading and others are visual learners. Reading learners may be able to acquire all the skills they need by simply reading this book and copying what they see. Visual learners will find it helpful to supplement this book with the companion videos. The videos will allow you to watch my hand up close while I draw and see how I make my strokes, how hard I press, when I turn the paper, etc. The three companion videos for this book demonstrate several of the drawings in this book. They are *Drawing Basics, The Easy Way To Draw Animals* and *The Easy Way To Draw Flowers, Water and Landscapes*. (See the back of the book for ordering info.)

Seven: Because most people who buy this book are time conscious, I have broken the exercises down into a set of bite sized lessons. If you want to follow a regime, simply complete one drawing per day. Most folks can complete the entire book within 90 days if they practice 45 minutes to one hour each day. As your work improves, you'll find yourself looking forward to this refreshing hour each day. Art has tremendous therapeutic values. You'll be surprised how fast time flies when you are drawing and how refreshed you will feel afterwards.

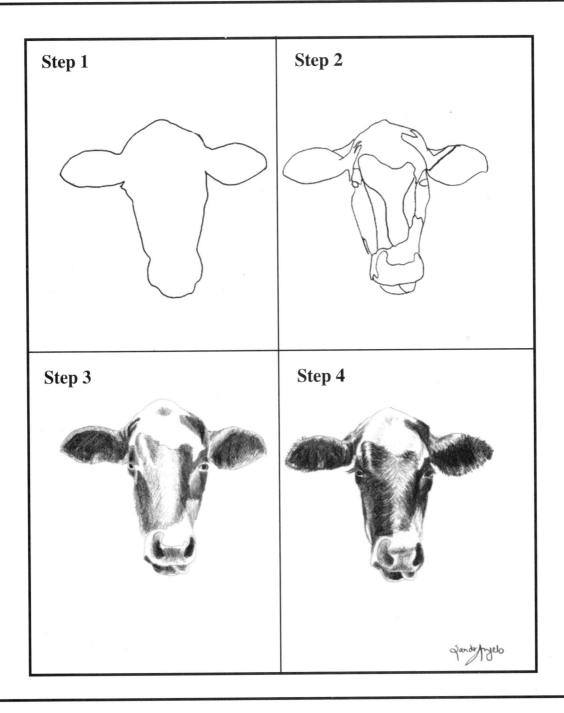

Figure 35 —This progressive drawing of the cow shows the four step process that most beginners use. First the negative space is established, then the contour lines are added, next a study of the light and dark values is completed and the textures are put on last.

Shape Exercises
(Aerobics for artists)

T I P When you draw with a grid, concentrate on one square at a time. As a general rule it is best to start with the section which looks easiest to you. That way, your success will build confidence quickly and you will be ready when you reach the tougher stuff.

If you are having problems with accuracy, think about using a drawing window. To do this:

1) Use an 8 1/2 x 11 sheet of paper (or one side of a manila file folder, because it's sturdier than paper).

2) In the center of the folder, cut a square window that is the same size as your grid square, (i.e. If you are using a one half inch grid, you would cut a one half inch window in the middle of your 8 1/2 x 11 folder.)

3) Place this window over your drawing reference so that you can only see one grid square at a time. This will block out the rest of the drawing and force you to concentrate on only the square you are drawing.

You can peek underneath periodically to make sure you are in the right square, but you should not analyze your drawing or make corrections until you have finished the entire drawing. If you follow this procedure exactly, (without analyzing or correcting while you draw), you will be amazed at your accurate results.

Using a window can seem tedious but it is actually training you to see shapes, lines, and values just like artists see them. Soon you will see them without having to use the window. Like the grid, the window is a training tool.

Shape Exercise

In box 2, draw the negative space of the lamp with the grid. When you are doing this negative space drawing remember to focus on the black space while you draw. You will draw more accurately if you draw the space behind the object rather than the object itself. I have made this negative space black so that it is easier to identify it as a shape.

In box four, draw the lamp again, without a grid this time. Did you get more accuracy with or without the grid? If you were more accurate using the grid, you will probably need to use one for most of the lessons. If you did ok without it, try a few more without a grid. See which method gives you the most accurate results.

Shape Exercise

In the first box, you will see the object you are to draw. Do a negative space drawing of this object in the second box, using the grid. Then try drawing it without the grid in the box below.

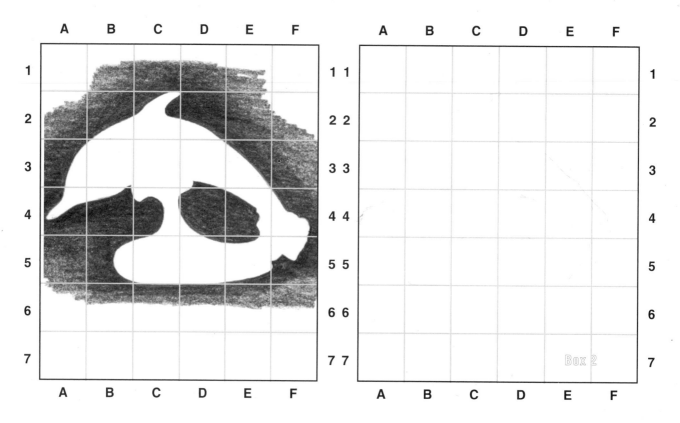

Try again, without the grid.

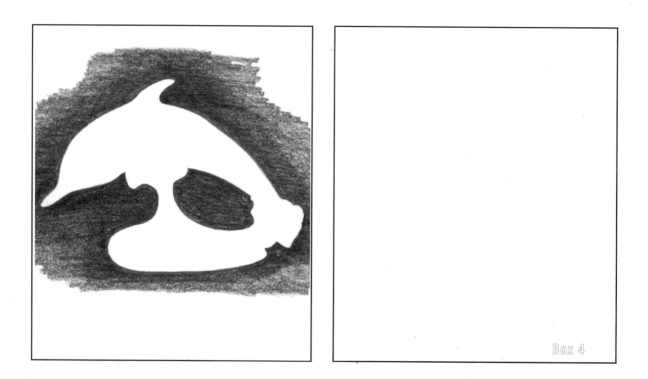

Shape Exercise

In the first box, you will see the object you are to draw. Do a negative space drawing of this object in the second box, using the grid. Then try drawing it without the grid in the box below.

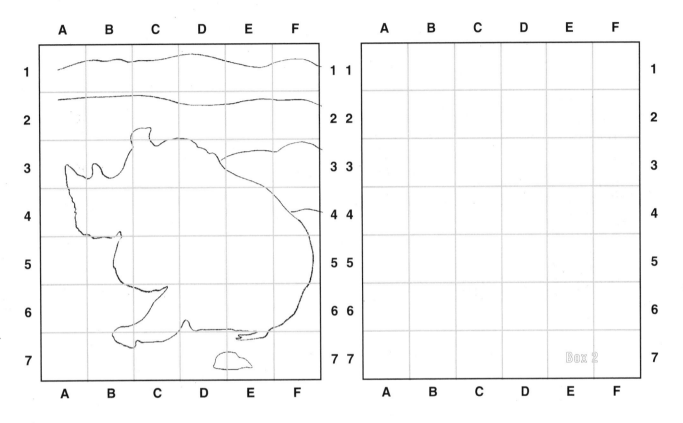

Try again, without the grid.

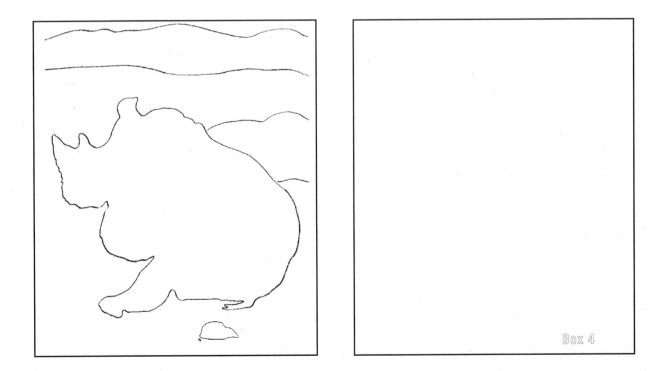

Shape Exercise

In the first box, you will see the object you are to draw. Do a negative space drawing of this object in the second box, using the grid. Then try drawing it without the grid in the box below. (It's okay to use a ruler.)

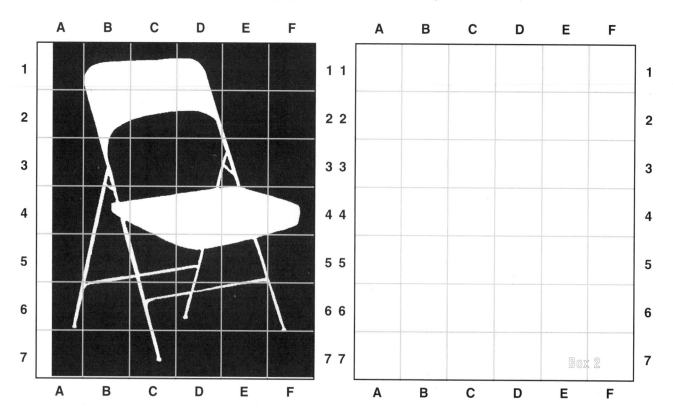

Try again, without the grid.

Shape Exercise

Now try doing a NEGATIVE space drawing by looking at the final drawing of the elephant. Remember to concentrate on the white space, not on the elephant. Draw only the silhouette.

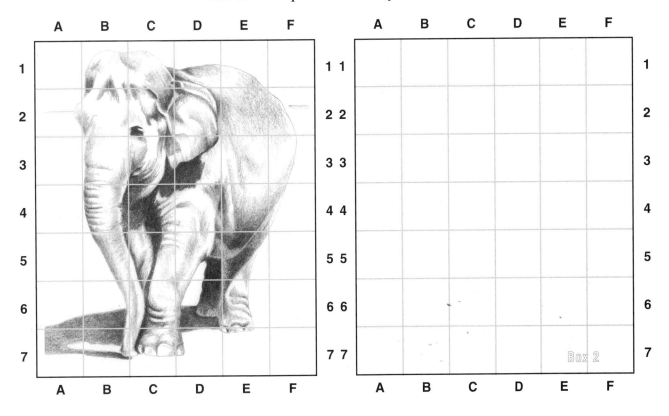

Try again, without the grid this time.

Box 4

Drawing by Sandra Angelo

CHAPTER FOUR

CONTOUR LINE DRAWING

SEEING LINES

Most artists begin their drawing by laying down an elaborate map which dictates where they will place their shapes and shadows. Reducing an object to its simple line elements helps the artist solve the proportion and placement problems before shading. These drawings, which show both the interior and exterior lines of an object, are called contour line drawings. If you want to impress your friends, casually refer to your line drawings as a collection of contour line drawings. This sort of conversation makes for great repartée over cocktails with your boss, a date, or anyone you're trying to amaze.

In Figure 36 you see a negative space drawing of the rabbit. In Figure 37 we filled in the interior contour lines. These lines will later serve as a map for placement of our interior shapes & shadows.

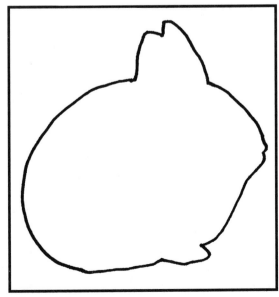

Figure 36

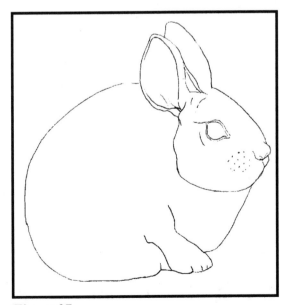

Figure 37

Line Exercises

In the first box, you will see the object you are to draw. Do a negative space drawing of this object in box 2, using the grid. In the same box, fill in the interior contour lines to establish a map for your shapes and shadows. Then try this same drawing without the grid in the box below.

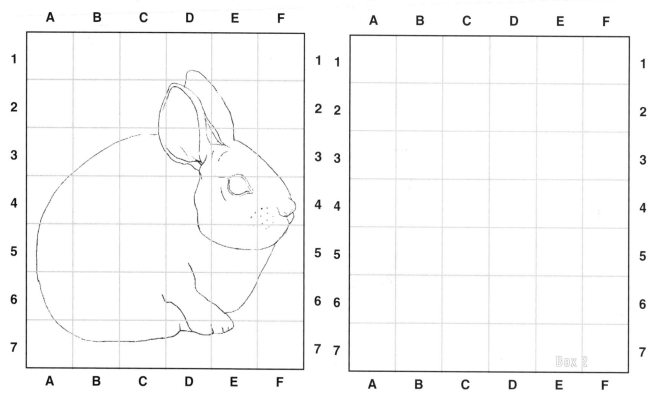

If you want to try the same drawing now without the grid, give it a whirl.

Line Exercise

Copy the contour line drawing.

If you want to try the same drawing now without the grid, give it a whirl.

Line Exercise

Copy the contour line drawing.

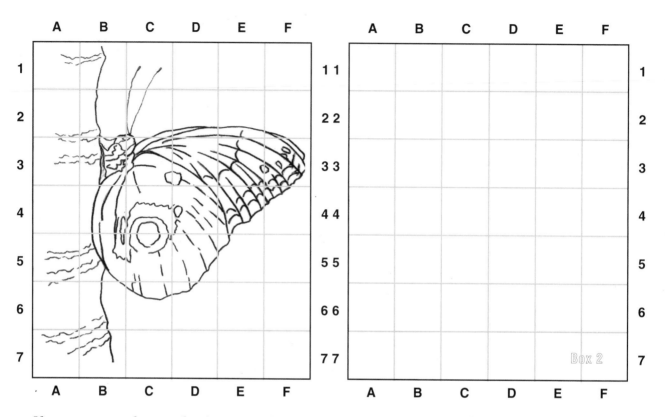

If you want to try the same drawing now without the grid, give it a whirl.

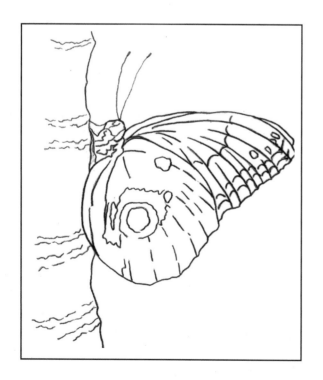

Line Exercise

Copy the contour line drawing.

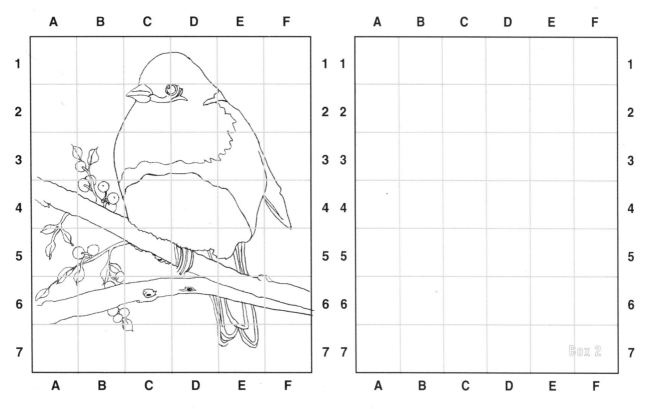

If you want to try the same drawing now without the grid, give it a whirl.

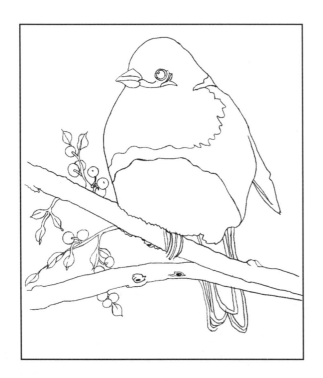

CHAPTER FIVE

VALUE DRAWING

LEARNING TO SHADE

In the art world, shading is referred to as a value study. To show the world how savvy you are, go around referring to shadows as deep values. Look into your loved one's baby blue eyes and say, ' What light values you have, my dear.' (If he responds, 'All the better to see you with, my dear,' beware!)

Learning to see the light and dark values in the objects that you draw is absolutely crucial because drawings and paintings with a full range of values have much more dimension and depth to them. Understanding how to create value will provide the foundation for all your future art endeavors. Or as my old crotchety art teacher, Mr. Dingleberry used to say, 'You need to take a second look at your values, honey.'

What do you mean you want to change my values..?

To avoid a rainbow effect like the one you see in Figure 38, go back over the section where values change and blend the two neighboring values together like the ball in Figure 39.

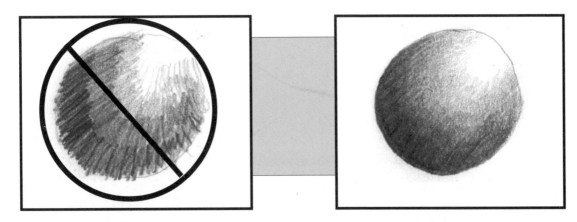

Figure 38 *Figure 39*

Photo by Sandra Angelo ©1989

Figure 40

When you look at the photograph in Figure 40 you will see that there are many shades of black, white and grey. Using a scale of one to ten, with one being white and ten being solid black, rate each shape and shadow that you see. If you can accurately draw these values the way they appear in the picture, your drawing will have depth and it will look three dimensional. If, like most beginners, you use all medium values, your drawing will look flat like the drawing in Figure 38. Look at how much more dimension there is in the drawing in Figure 39.

It is interesting to note that you will use this same rating system to determine your values even when you switch to color and begin painting with watercolors, acrylics, oils, pastels, colored pencils, and all other art media. That's why it is so crucial for you to learn to see every shape and shadow in terms of its value rating.

Shading Exercises

Are you afraid of the dark...?

Most beginning artists are terrified to draw dark values because they feel dark mistakes are much worse than light ones. As we just said, unless a drawing or painting has a wide range of light and dark values, it will look flat and lifeless. The most common mistake among beginners is the lack of depth in their values.

To learn how to use a pencil to create light and dark values, let's begin by practicing our value scales.

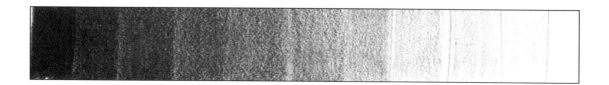

Shading Exercise

Instructions: Using your 2B + 4B or medium pencil, create 10 different values in the boxes below. You can copy from the value scale above.

Shading Exercise

Now try the same exercise with your 6B, 7B + 9B. I have provided several practice boxes so that you can keep trying this exercise until you get exactly 10 different values. You can copy from the value scale above.

T I P

To shade an object with even tones that gradually move from light to dark, use a shading technique called 'gradation'. Gradation simply means to shade without showing your lines. The easiest way to graduate your values is to move your pencil back and forth, blending the adjacent lines so that no texture shows. You can change the lightness or darkness of your value by pressing harder or lighter on your pencil. (When I graduate my values, I don't lift my pencil off the paper at all.)

CREATING DEPTH IN YOUR DRAWING

How do I make it look round?

There are four ways to shade which will create depth in your drawing.

One: If you use a gradual change in value from dark to light, your object will begin to look round. See the ball in Figure 42.

Two: You must have a wide range of values in your shading. Look at the ball in Figure 41. Because there are only a couple values, the ball looks flat. By contrast, the ball in Figure 42 has a wide range of lights and darks, making it look very round.

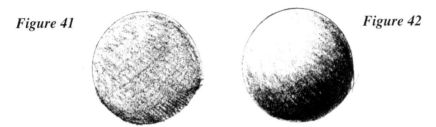

Figure 41 *Figure 42*

Three: Your pencil strokes should always follow the contour of the object. In Figure 43 the pencil strokes go every which way. The ball looks flat. In Figure 44 the strokes follow the contour of the ball. This ball is beginning to look round.

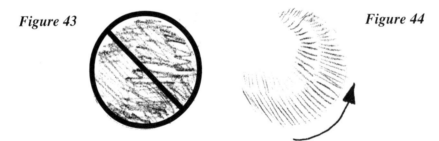

Figure 43 *Figure 44*

Four: If you place dark at both edges and light in the middle, your object will look round like the cylinder in Figure 46. In Figure 45 the cylinder only has one value so it looks flat. (Notice too that the bottom on the cylinder is flat while the top is round. This is the way most beginners draw cylinders. The correct way to draw a cylinder is to make sure the arc of the ellipse at the top of the cylinder is the same as the curvature of the ellipse at the bottom just like the cylinder in Figure 46.)

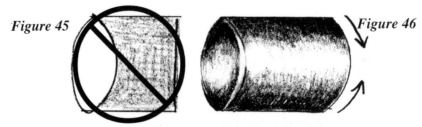

Figure 45 *Figure 46*

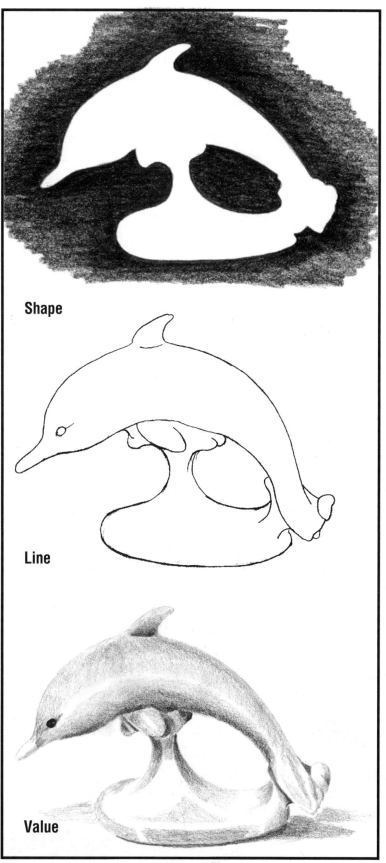

Shape

Line

Value

Drawings by Gré Hann

Instructions for shading exercises

Instructions: On the following pages, in box 1, you will see the object you are to copy. In box 2, using the grid, draw the negative space first, then in the same box, fill in the contour lines which delineate a map for shading. Next shade your drawing within the contour lines you have just established. Figure 47 demonstrates the sequence you will follow.

Now copy all the value drawings in this chapter.

Figure 47

Although your lines don't show when you graduate your values, it is important to shade in the proper direction so as to sculpt the object with your lines. In Box one you see a diagram which shows the contour line drawing of the pepper. Copy this in box 4. In Box 2, you will see a diagram that shows you which direction your strokes will take when you shade the pepper in Box 4. Don't use lines like the diagram, copy the shading style in Box 3 but make your shading follow the directions indicated in Box 2.

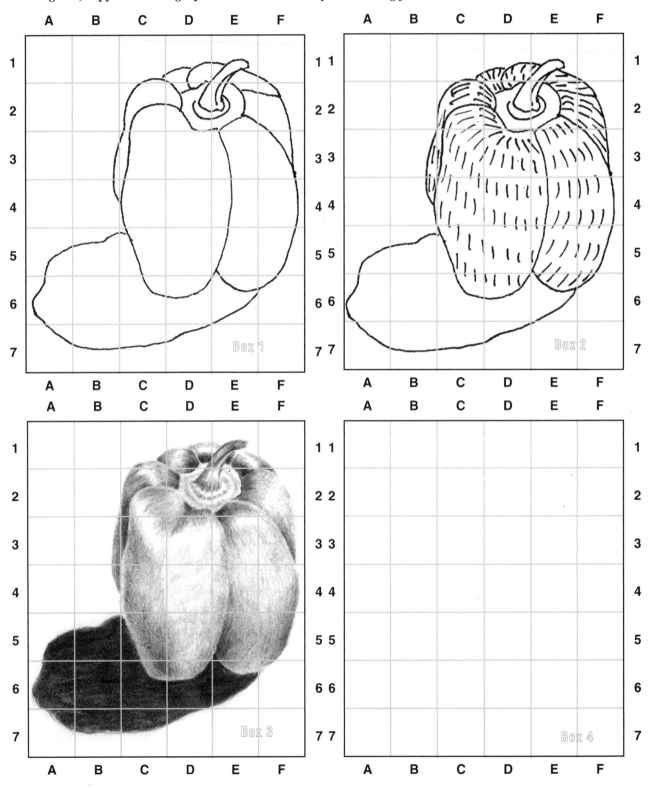

Value Exercises

Copy these drawings to learn shading techniques.

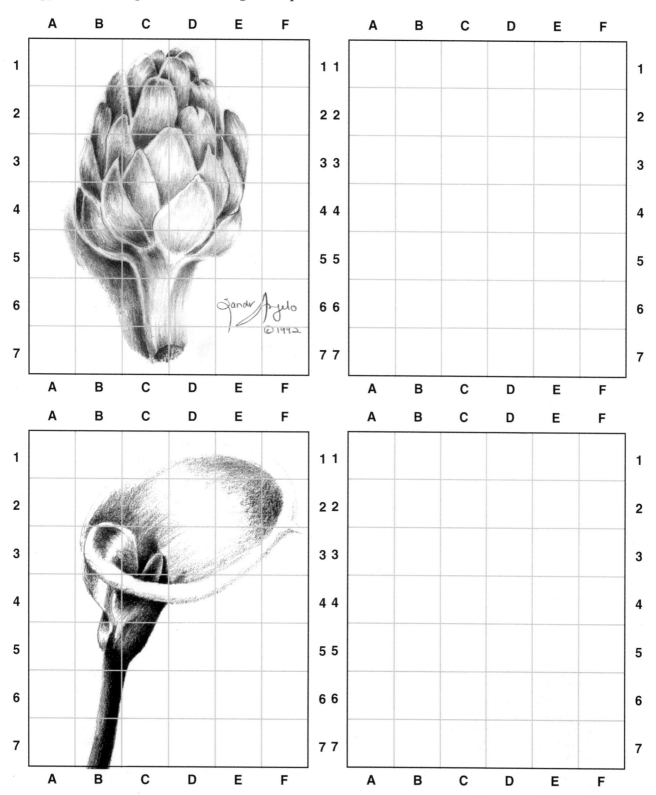

Value Exercises

Try these drawings on the practice paper. If it seems too hard, consider practicing just a few of the parts of the drawing.

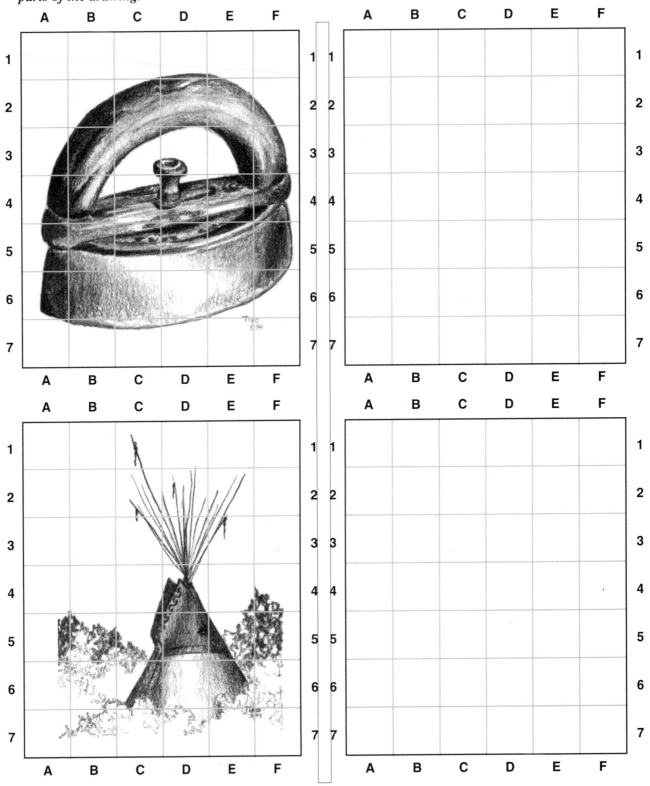

Value Exercise

Copy this value drawing in box 2 below.

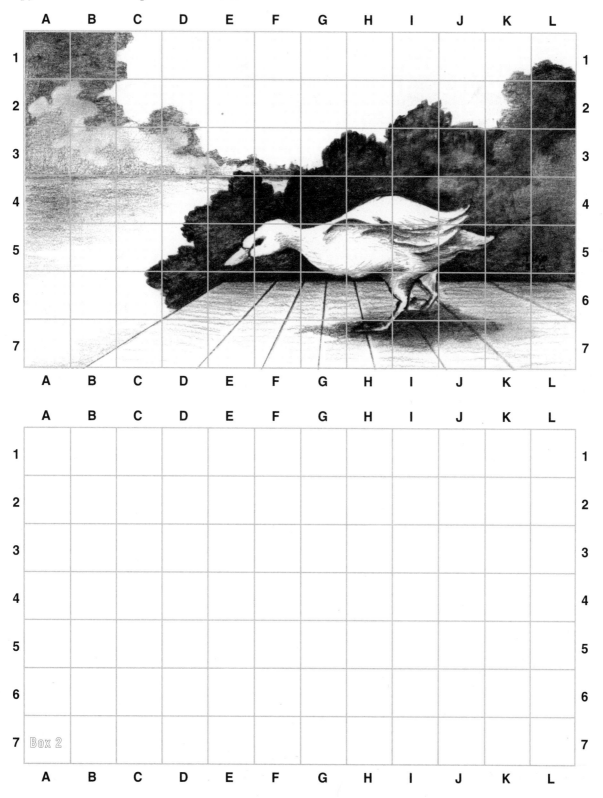

Drawing by Tiko Youngdale.

Value Exercise

Copy this value drawing in box 2 below.

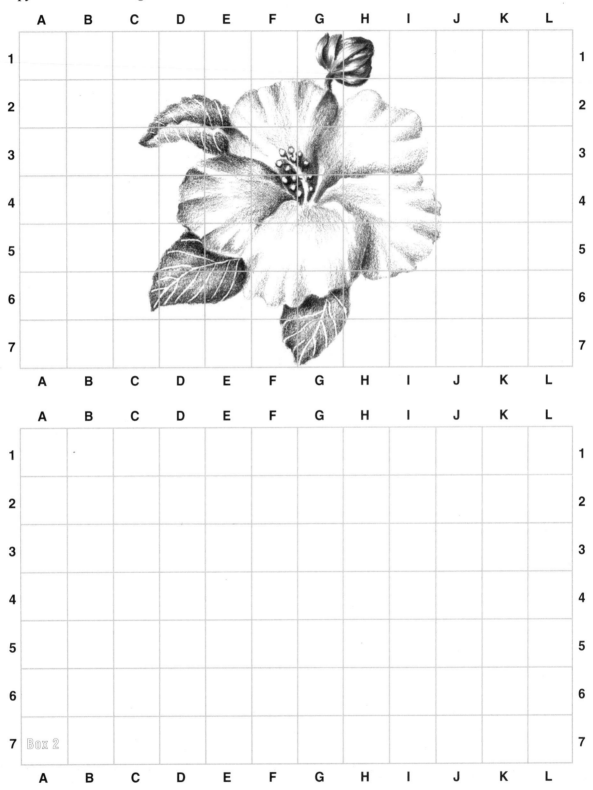

Drawing by Sandra Angelo

Value Exercise

Copy these value drawings in the boxes provided

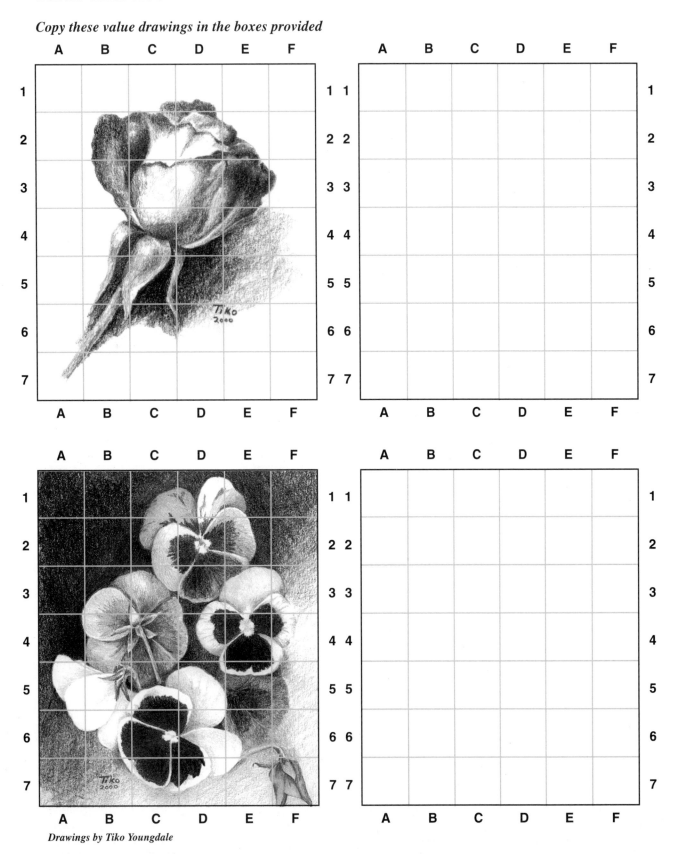

Drawings by Tiko Youngdale

CHAPTER SIX

CREATING TEXTURE

Fluffy flamingo feathers. Uncle Delbert's droopy jowls. Spido's cold wet nose. Dangling cellulite. Einstein's bad hair day. How do you create these various textures with the humble pencil?

Artists have come up with all kinds of elaborate strokes to simulate the textures they see around them, but the most commonly used textures are hatching and gradation.

Gradation: As we explained earlier, to graduate your strokes, use small circular marks, never lifting your pencil off the paper. Blend your strokes so that the lines do not show, thus creating a soft graduated value, i.e. the cat in Figure 48. As a general rule, this technique is used for objects that have smooth textures like the folds in fabric, saggy, baggy, skin, a peach, a green pepper, a baby's cheeks, etc.

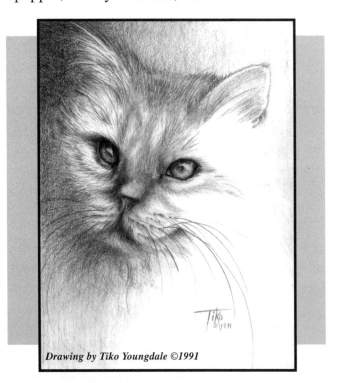

Drawing by Tiko Youngdale ©1991

Figure 48

Hatching: To create hatching lines, lift the pencil off the paper with each stroke allowing your lines to show. To change the lightness or darkness of your lines, simply use light, medium or heavy pressure on your pencil. See Figure 49. Another way to change values is to space the lines farther apart for light values and place them closer together to make the values dark. See Figure 50. As a general rule, hatching is used for objects which have a linear texture like human hair, grass, needles on a pine branch, a shaggy dog, a fluffy cat, Uncle Mortimer's toupee, etc.

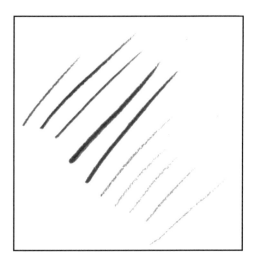

Fig. 49

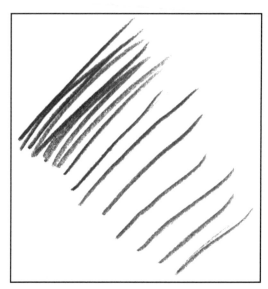

Fig. 50

Exercise Twenty-one:

Practice graduating your values by shading the rocks on page 69. If you'd like, you may draw the negative shape first, then draw the contour lines, and finally shade the values with graduated strokes. Blend your lines so they don't show. This will simulate the soft texture of these boulders. Remember, to get a dark value, press harder, to lighten your values, ease up on your pencil pressure.

TIP Never smudge your pencil lines with your fingers. Your B pencils (as in 2B, 3B, 4B...) will give you soft graduated values if you just keep going back over your lines, blending them gently. (The reason you have an impulse to smudge is because you are used to using the common HB household pencil. No matter how hard you tried, that pencil never blended unless you smudged with your finger.)

Shade these rocks with gradated values. Use hatching lines for the grass.

Now practice hatching by adding the grass to your rock drawing. Be sure to make your strokes go in various directions. Grass does not grow straight up. You can vary your values by changing your pencil pressure or by placing the strokes further apart. If you have a battery operated eraser, take out some of the dark values in the grass with the eraser.

Exercise Twenty-two:

There are other ways to create texture. You can vary your pencil pressure, twist it, push it, lay it on its side, etc. On page 80, try playing with your pencil to see how many different textures you can create by varying your strokes. Underneath each texture, describe how you created that texture. Then write down some uses for that type of stroke. For example, in Figure 51 you'll see that I laid the pencil on its side to simulate the bamboo handle. I then used the point of the pencil to create the goat hair brush.

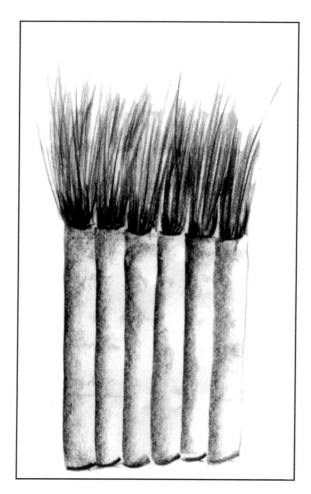

Figure 51: I used the side of my pencil to draw the bamboo handle and the point of my pencil to create the goat hair brush.

Look at the variety of textures I created by varying my pencil strokes. Next to my textures, I wrote down possible applications for these strokes.

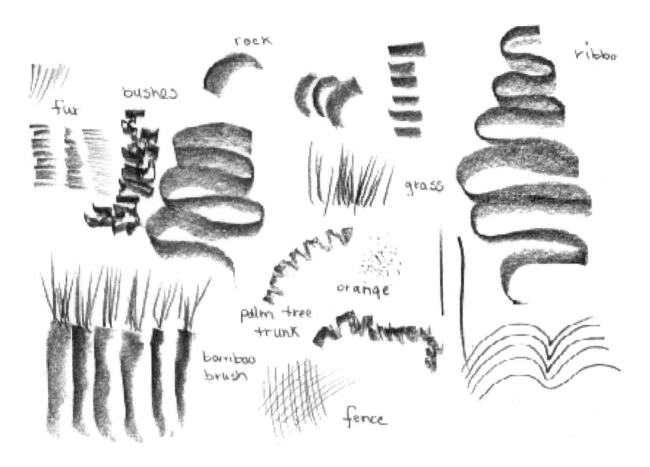

Now it's your turn. Fill this page with a variety of textures, using different kinds of strokes. For future reference, write down how you achieved each texture and ways you might use these marks in your drawings.

Begin to notice textures around you ...

Look at the four animals in Figures 52 through 55. Even though each of them have a linear hair pattern, every kind of fur has a different texture. Each animal's hair requires a different stroke.

Figure 52 *Figure 53*

Tiko

Figure 54 *Figure 55*

Even though all of these animals are covered with fur, the texture in each case is very different.

CHAPTER SEVEN

EXERCISE SECTION

TIME TO PRACTICE

Now you are going to practice texture by copying a wide variety of subjects. The following pages are full of drawings for you to copy. If you want to, you can use my four step drawing system for each of these drawings: 1) begin with the negative space 2) fill in the contour lines 3) shade the object and 4) apply the texture.

If you feel overwhelmed by any of the drawings, just practice parts of it, such as the tail, one leaf, one pumpkin, etc. After you practice the individual parts, you may be ready to tackle the whole drawing.

You don't have to do every drawing. Start with the ones which look easy and fun to draw. We all draw better if we are drawing something we like. An artist who loves landscapes may draw faces very poorly simply because she doesn't enjoy it. We all do best at what we love so stay with the subjects that you enjoy until you have built some confidence and are ready to tackle more difficult drawings. If you like one of the subjects more than the others, try practicing it several times. You will improve your skills each time.

I have tried to group the drawings in their order of relative difficulty. For those of you who like structure, just follow the drawings in sequence. If you don't feel like going through the book sequentially, choose the drawings you like and do those first. Starting with easy drawings is critical, since it will insure success. Success breeds self confidence and confidence motivates you to practice. Practice creates an artist.

Instructions
For
Exercises

PART ONE

Practice makes artists.

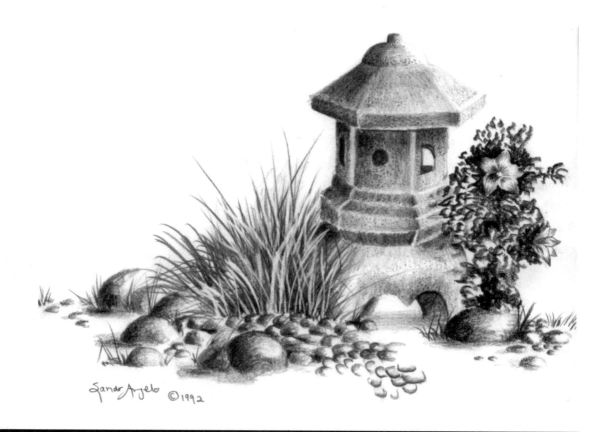

Sandra Angelo ©1992

The following pages are filled with a variety of drawings for you to copy. Start with the subjects that you enjoy. If your first attempt isn't satisfactory, try practicing the parts; the tail, the ears, the legs, etc. Then try the drawing again.

Some beginners will end up becoming impressionists, meaning they will draw with loose lines like the ones Gré Hann used to shade her rabbit on page 87. People who like to use sketchy lines hate to draw small. If you fit into that category, you can do these exercises in a separate sketch book. Make the drawings as large as you like. For those of you who are Realists, you wil be just fine drawing the petite, exact renderings in this book.

Remember to keep your sketch book private so that you will feel comfortable making mistakes. Review and follow the rest of the exercise instructions on page 41. If you get stuck on a subject, move on to something easier. Keep drawing the things you love because if you love it, you will make time for it and if you put in the time, you will automatically learn to draw.

If you get stumped, try eating a bowl of ice cream or a batch of chocolate chip cookies. Your drawing may not look better, but you'll feel great. Most of all, enjoy your drawing time. In the beginning, drawing is a bit stressful because you're no good at it. However, as your skills improve, you will find it to be one of the most therapeutic and relaxing exercises you can enjoy. So turn this page, and have fun!

As you practice your drawing on the following pages, you may want to use the four step process, as illustrated in this drawing of the dog. Draw the negative space first to be sure your placement is accurate. In the same box, fill in a contour line drawing which will serve as a map for your shapes and shadows. Shade your light and dark values and then place the texture on top of these values. This four step method helps you analyze each object in terms of its shapes, lines, values and textures. Eventually, you won't need to use this process because you will have trained your eye to see these elements.

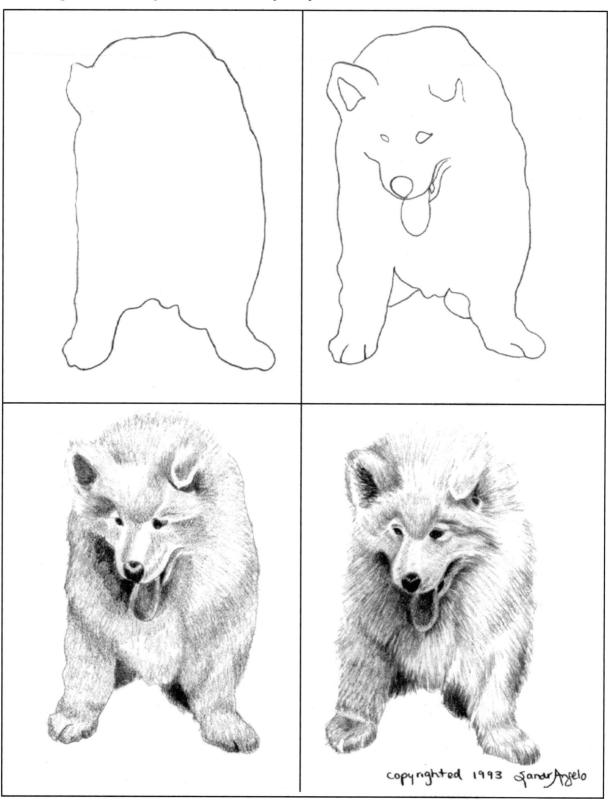

copyrighted 1993 Sandra Angelo

Fig. 57

Sometimes you only need three steps to complete a drawing, as in the flower below. In step one, I completed a negative space drawing. Then I created a map by putting in a contour line drawing, and finally I shaded the object. If your subject doesn't have a distinct texture, you can stop after step three.

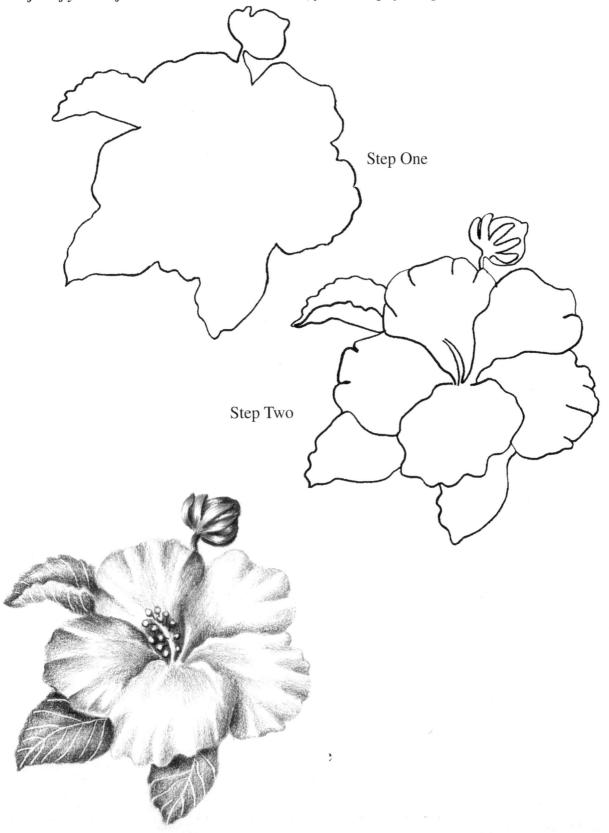

Step One

Step Two

In box 4, do a negative space drawing of the cow (see box 1). Then do a contour line drawing of the cow inside this negative space drawing (see box 2). Finally, shade the cow with the same textures you see in box 3.

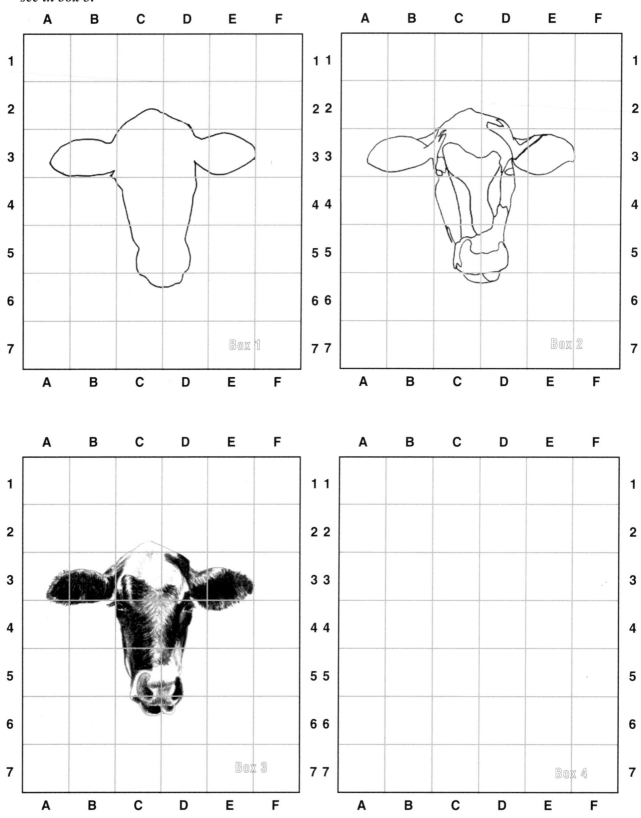

Try this drawing on the practice paper. If it seems too hard, consider practicing just a few of the parts of the drawing. If the subject doesn't interest you, you can skip to the next drawing.

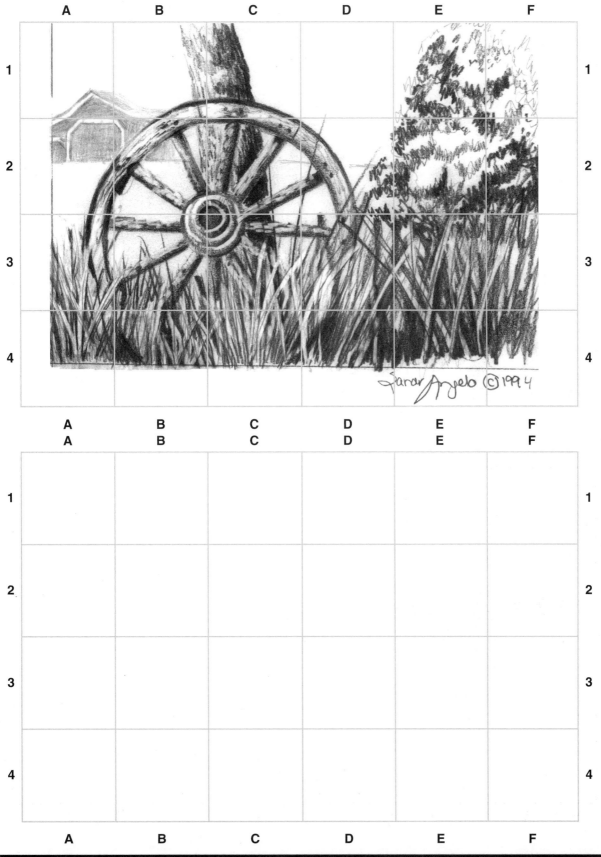

To make your life easier, I have provided a step-by-step drawing of this subject. In Box One, you will see the negative space drawing of the subject. Draw this negative space in Box Four. In Box Two, you will see a contour line drawing of the subject. Complete a line drawing inside the negative space in Box Four.

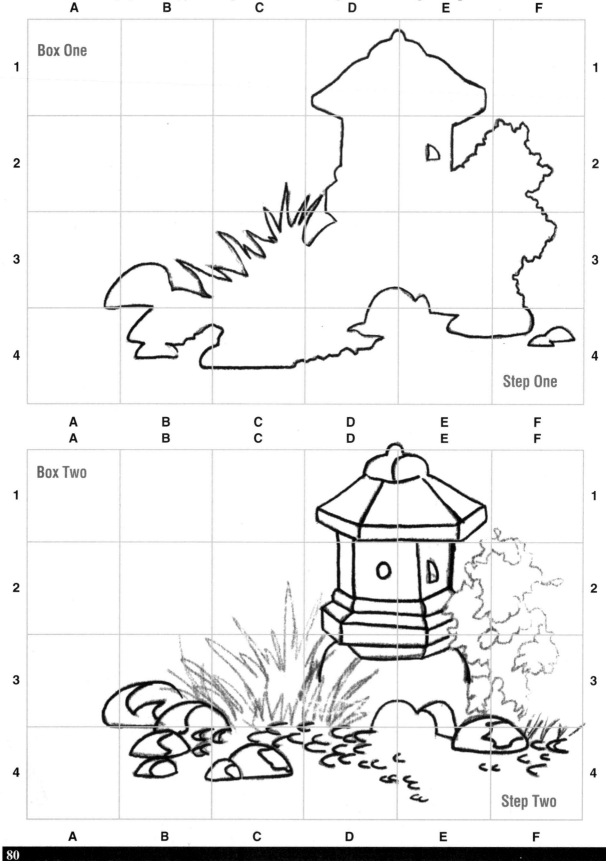

Box One

Step One

Box Two

Step Two

Place the values and textures inside the lines in Box Four.

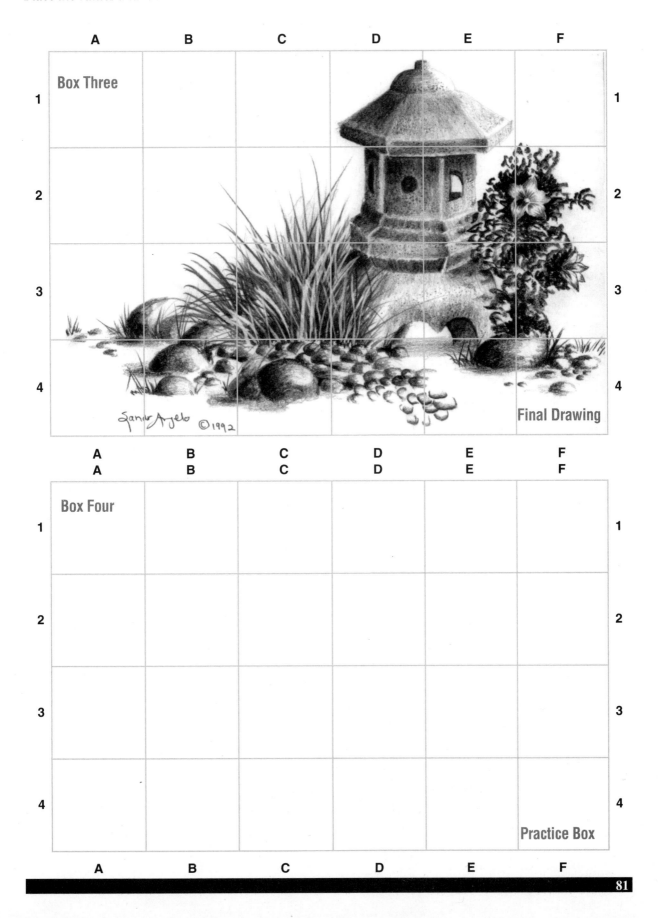

To make your life easier, I have provided a step-by-step drawing of this subject. In Box One, you will see the negative space drawing of the subject. Draw this negative space in Box Four. In Box Two, you will see a contour line drawing of the subject. Complete a line drawing inside the negative space in Box Four.

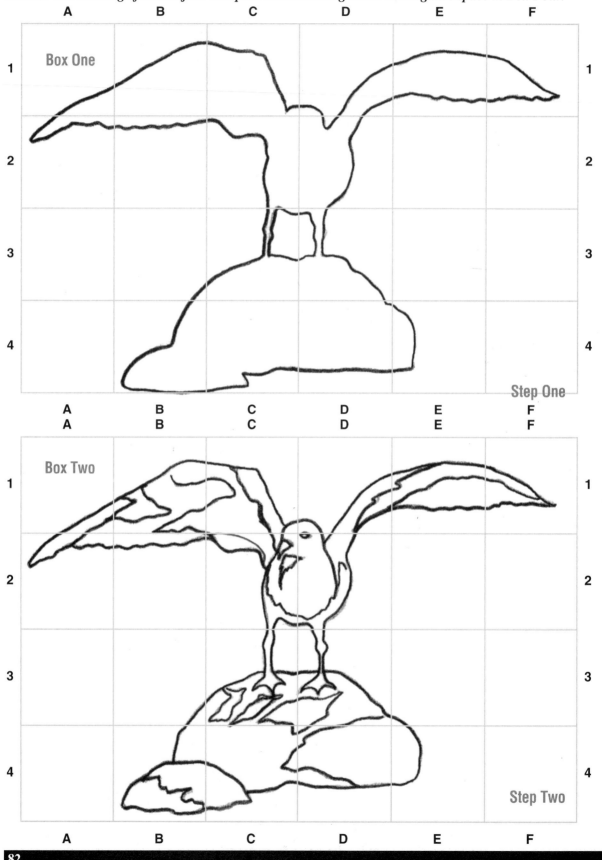

Place the values and textures inside the lines in Box Four.

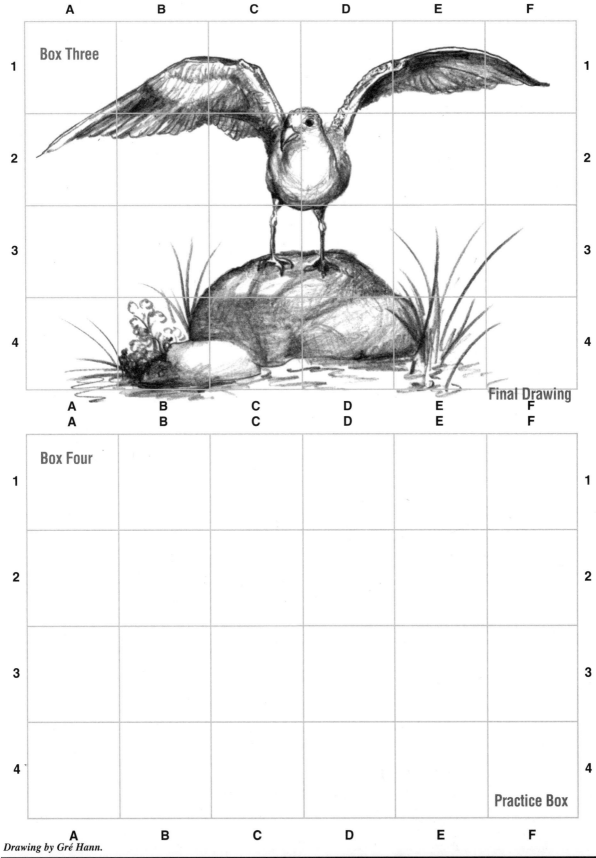

Box Three

Final Drawing

Box Four

Practice Box

Drawing by Gré Hann.

Copy this drawing on the following page

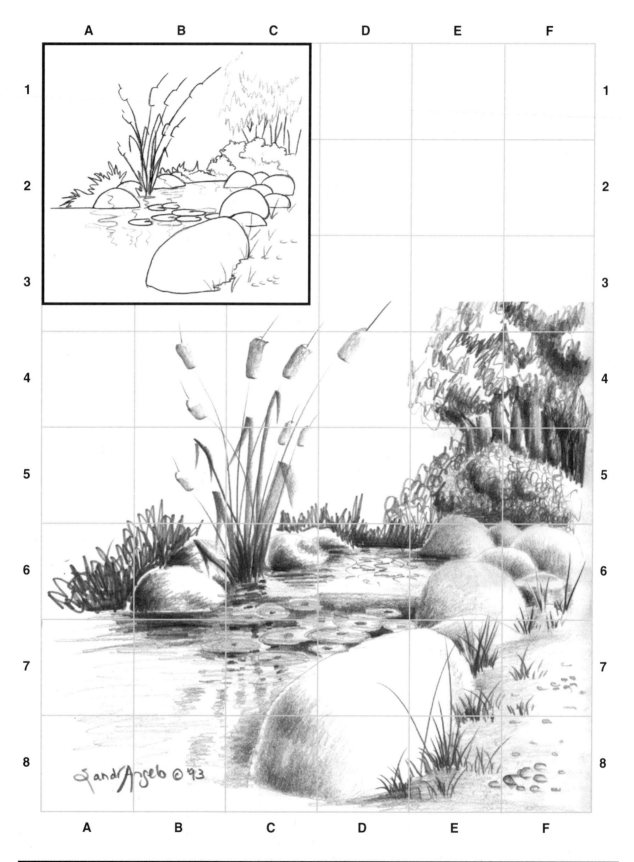

Practice Page

	A	B	C	D	E	F	
1							1
2							2
3							3
4							4
5							5
6							6
7							7
8							8
	A	B	C	D	E	F	

Draw this car in the box below.

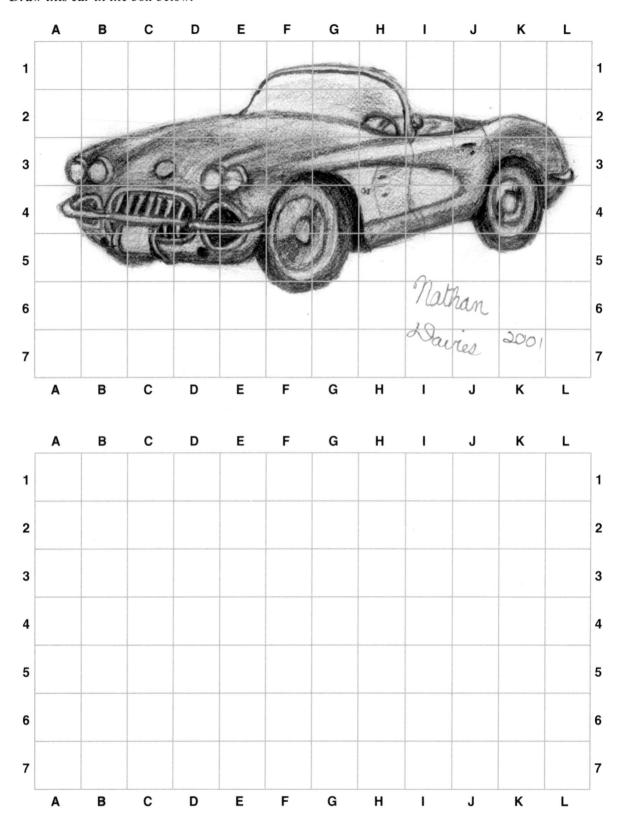

Copy this drawing in the box below.

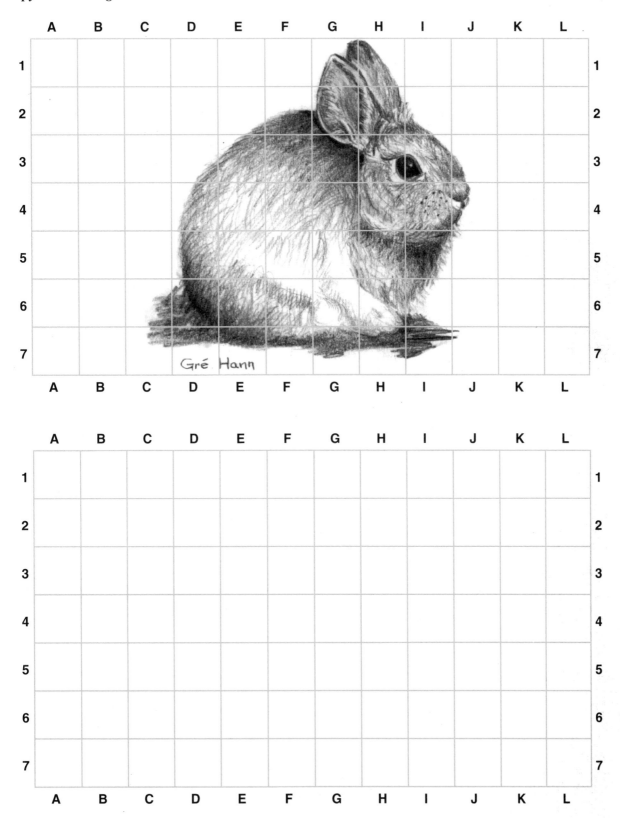

Copy these trees on the following page. If you're having trouble, practice small parts.

Practice Page

Copy these dogs in the gridded box on the adjacent page.

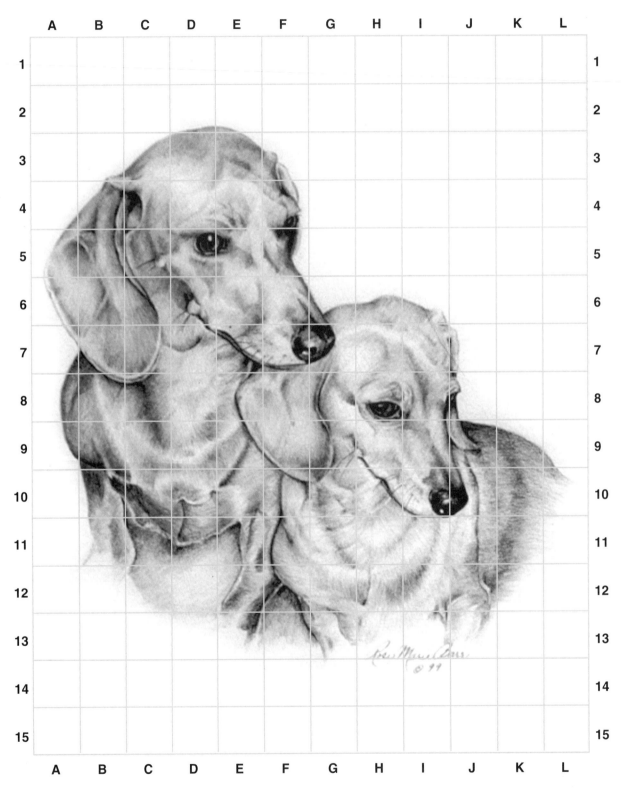

Drawing by Rose Marie Barr ©1998

Practice Page

Copy this drawing on the practice page.

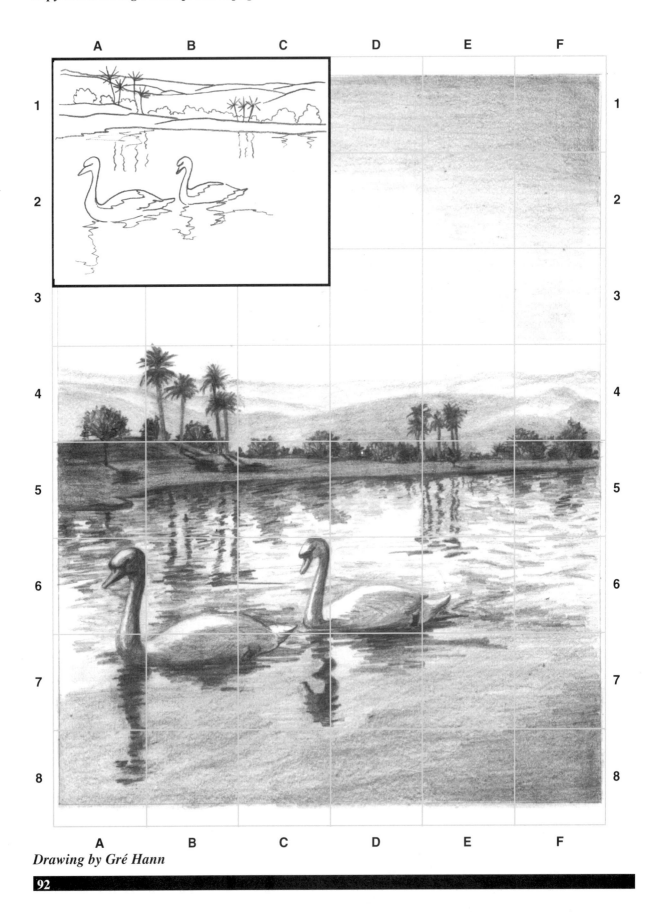

Drawing by Gré Hann

Practice Page

	A	B	C	D	E	F	
1							1
2							2
3							3
4							4
5							5
6							6
7							7
8							8
	A	B	C	D	E	F	

Copy this drawing on the practice page. If any of the squares are too complicated, subdivide them.

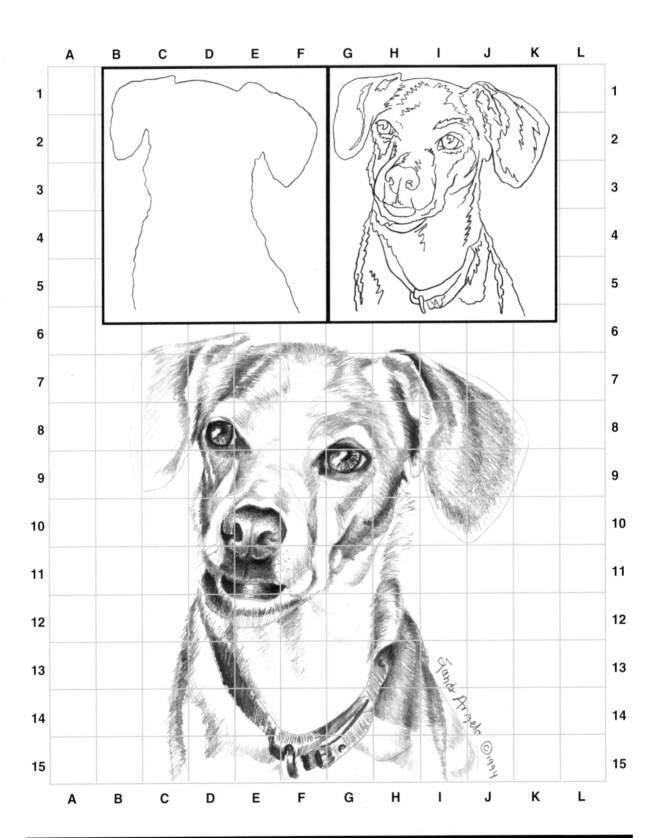

Practice Page

To make your life easier, I have provided a step-by-step drawing of this subject. In Box One, you will see the negative space drawing of the subject. Draw this negative space in Box Four. In Box Two, you will see a contour line drawing of the subject. Complete a line drawing inside the negative space in Box Four.

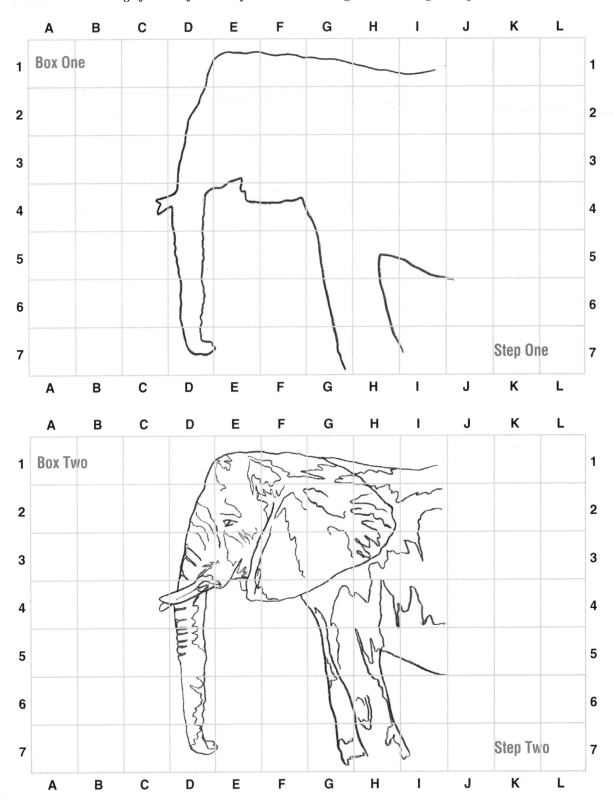

Place the values and textures inside the lines in Box Four.

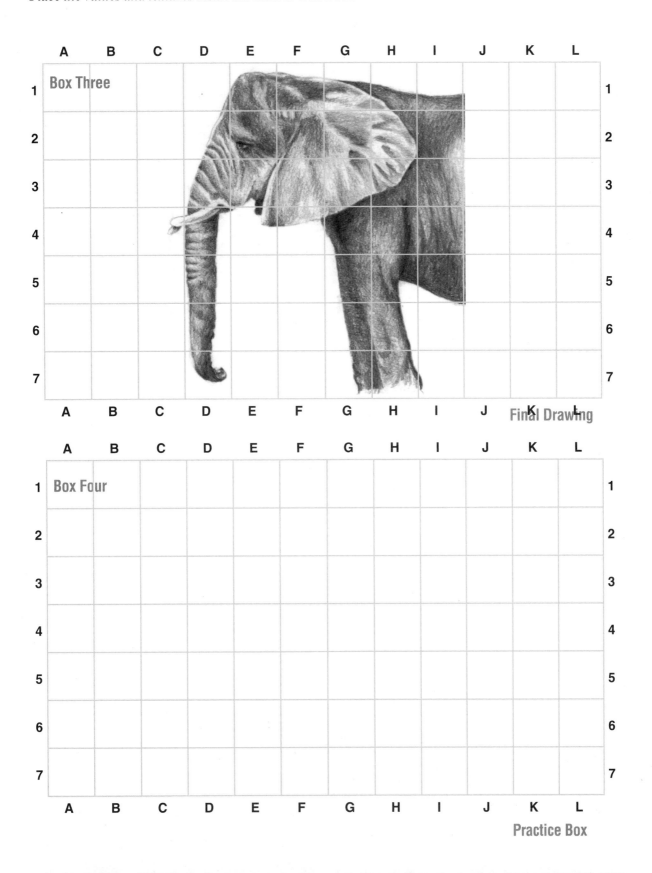

Copy this drawing on the practice page.

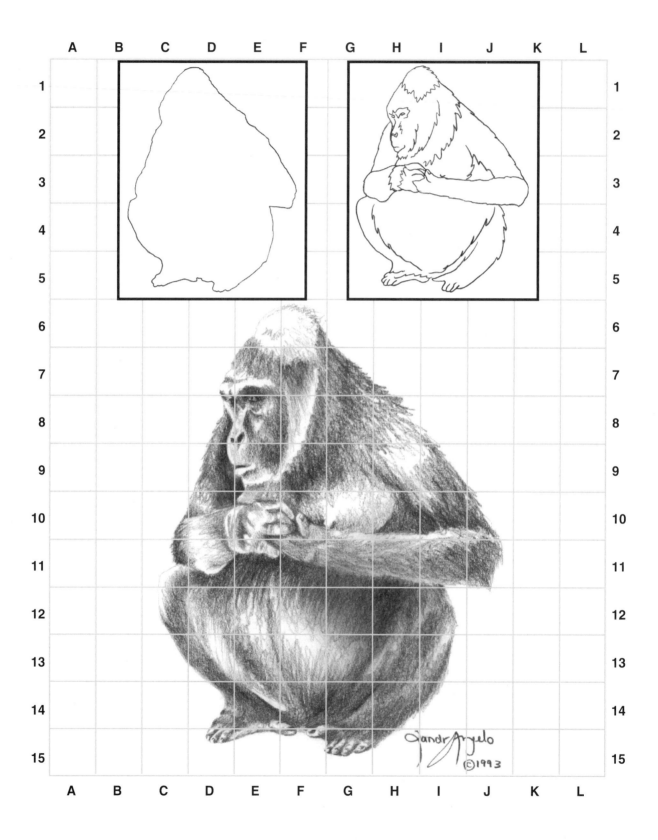

To make your life easier, I have provided a step-by-step drawing of this subject. In Box One, you will see the negative space drawing of the subject. Draw this negative space in Box Four. In Box Two, you will see the contour line drawing of the subject. Complete a line drawing inside the negative space in Box Four.

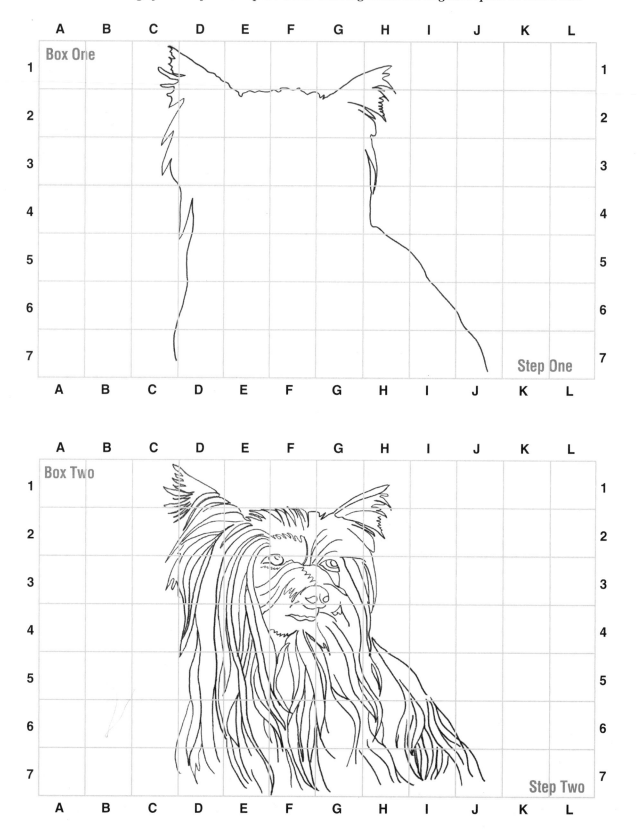

Place the values and textures inside the lines in Box Four.

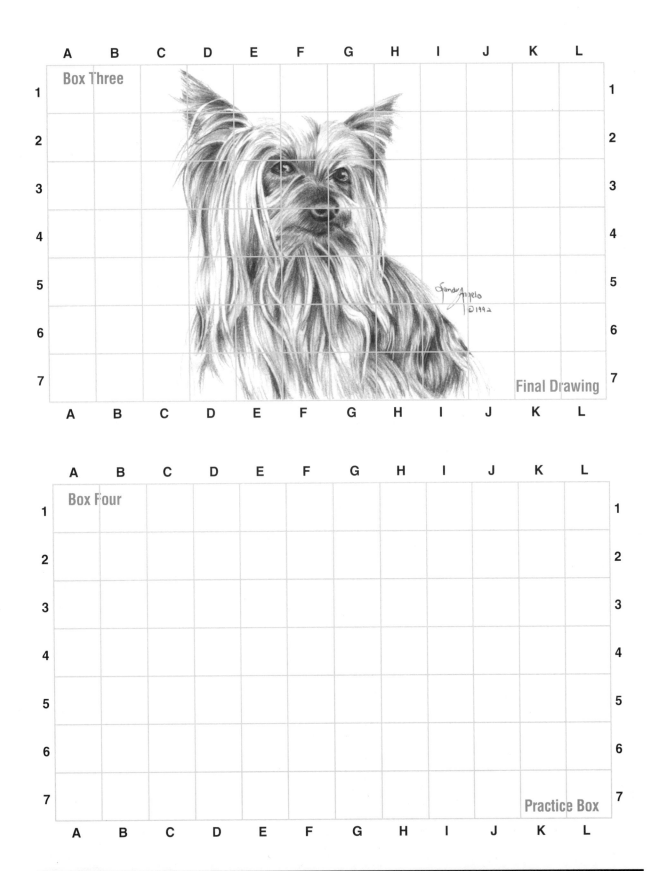

Practice this drawing on the following page.

Practice Page

Practice this drawing on the following page.

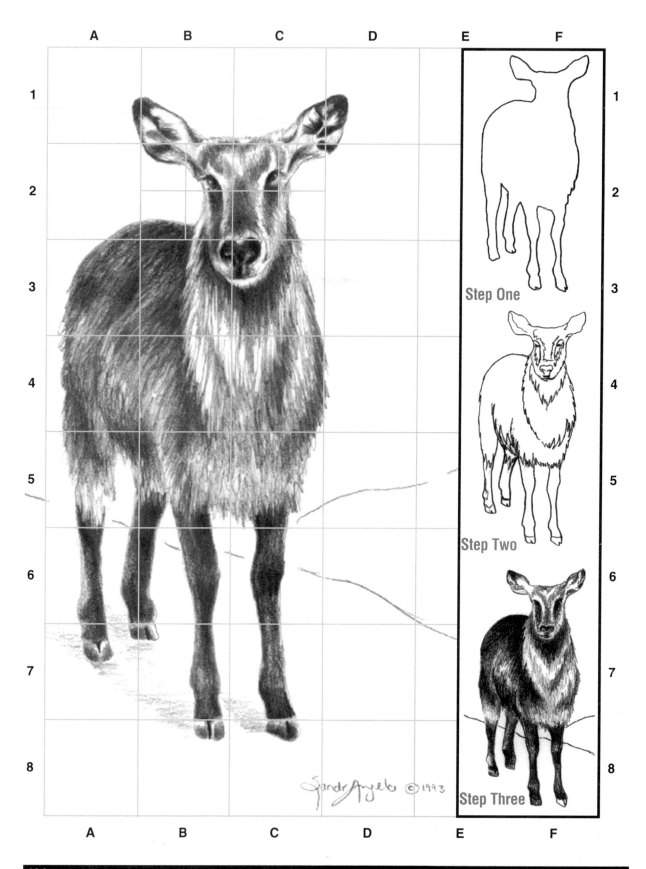

Step One

Step Two

Step Three

Practice Page

	A	B	C	D	E	F	
1							1
2							2
3							3
4							4
5							5
6							6
7							7
8							8

| | A | B | C | D | E | F |

Practice this drawing on the following page.

"Wallowa County" by Tiko Youngdale

Practice Page

	A	B	C	D	E	F	
1							1
2							2
3							3
4							4
5							5
6							6
7							7
8							8
	A	B	C	D	E	F	

Practice this drawing on the grid below.

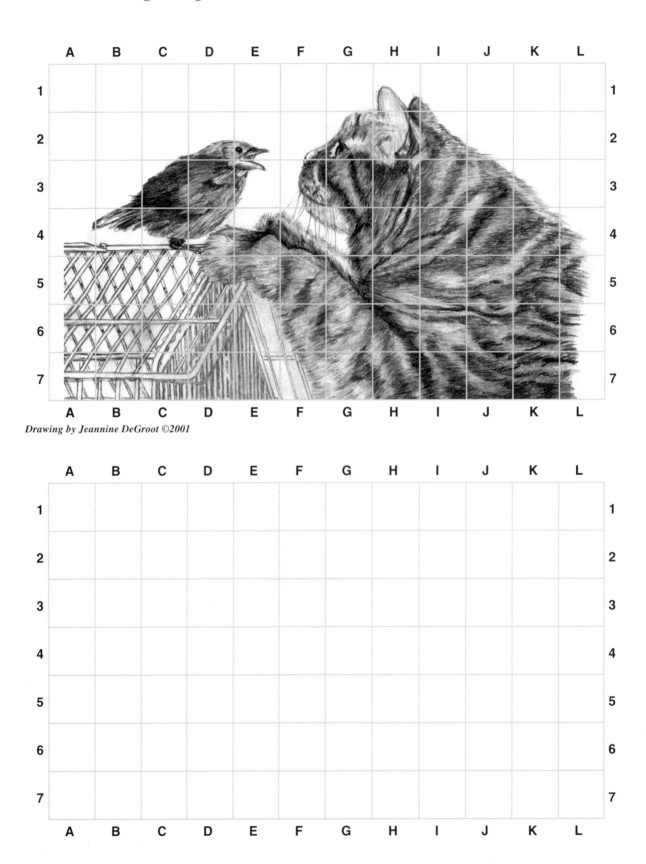

Drawing by Jeannine DeGroot ©2001

Practice this drawing on the grid below.

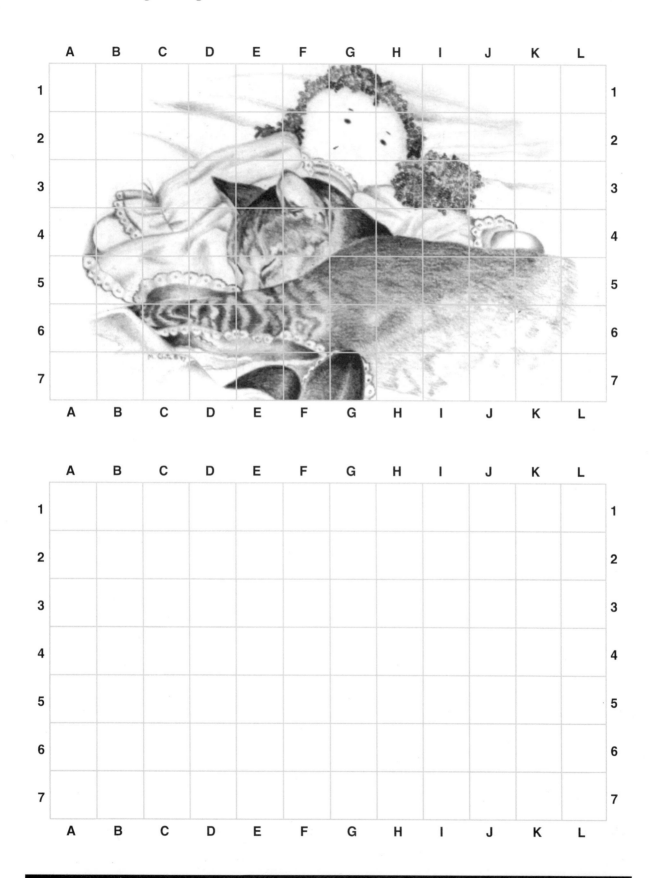

Copy this drawing on the practice page.

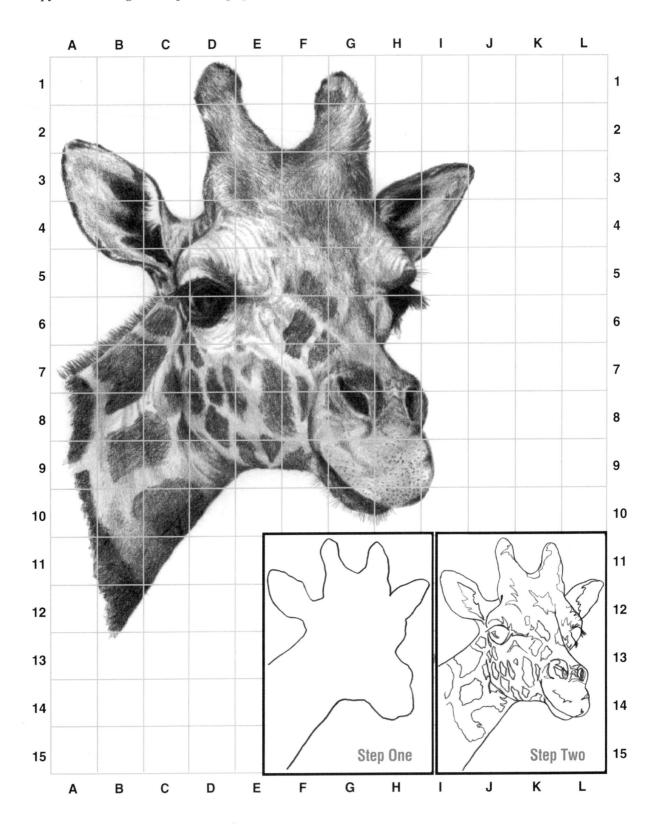

Step One

Step Two

Drawing by Tiko Youngdale.

Practice Page

Practice this drawing on the grid below.

Practice this drawing on the grid below.

Copy this drawing on the practice page.

Drawing by Tiko Youngdale.

Practice Page

	A	B	C	D	E	F
1						
2						
3						
4						
5						
6						
7						
8						

Practice this drawing on the following page.

Drawing by Gré Hann.

Practice Page

Practice this drawing on the following page.

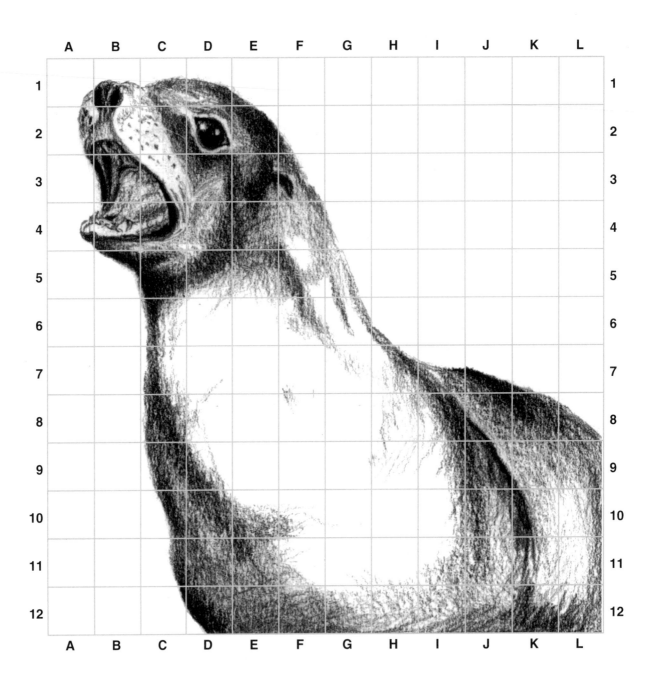

Drawing by Gré Hann.

Practice Page

Practice this drawing on the following page.

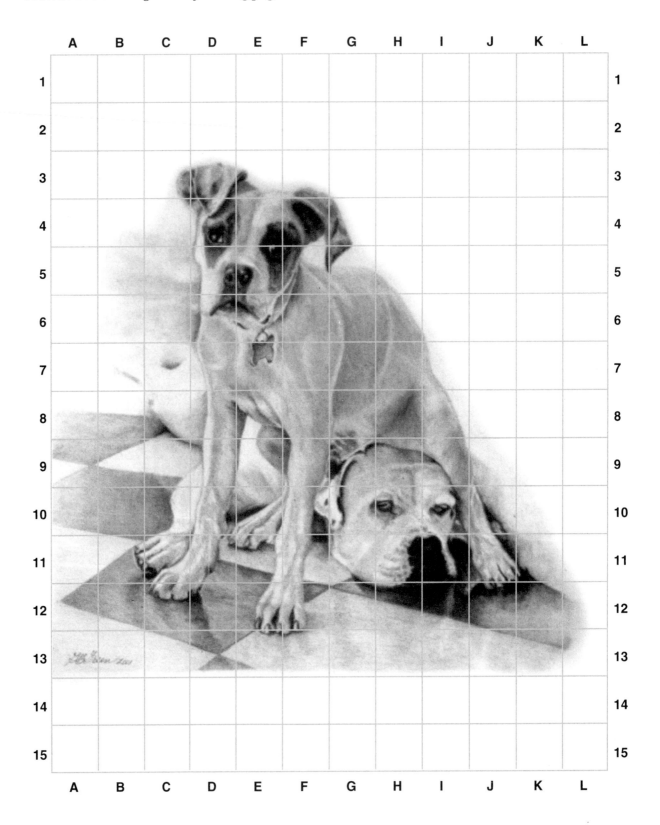

Drawing by Gloria Green.

Practice Page

If you love detail, you may enjoy copying this drawing by Tiko Youngdale. If you need to, you can draw a gridded practice sheet. (I suggest a 1/2 inch grid because of the minute detail).

CHAPTER EIGHT
Drawing From Photo References

Now that you've conquered copying the masters, try raising the level of difficulty by working from photos. This will be a bit harder because now you have to decide what kind of stroke you will use to create each texture. But your work with the masters has taught you a variety of shading techniques so you should be able to handle this transition fairly well. To make your move easier, I have made all the photos black and white, thus solving the value equation for you (how light or dark the item is).

This picture is typical of the photos most people take with a small home camera. The baby gorillas' heads are the size of the thumbnail on a small pinky finger. You simply can't draw from a photo like this because the subject isn't large enough to see the details. And to make matters worse, the lighting is very poor.

This close up of the gorilla is much better, because it's a 5x7 print, the subject fills the whole frame, the lighting is good, all of which contribute to more detailed information for drawing.

The photos I have supplied are fairly simple in terms of subject matter. When you finish these, I recommend that you draw from some of your own photos. Here are the rules you need to follow when selecting reference photos.

1. **A good photo equals a good drawing**. Memorize this. Countless hours are spent laboring over bad photos trying to create a good drawing. There are plenty of photos that are excellent references. Why waste your time on a bad one?

This is especially true for beginners. You must have early success to stay motivated and if your snapshots are complicated or poor quality, you will fail. If you don't succeed, drawing will become a chore instead of a pleasure, and you'll stop practicing.

2. **Make sure the photo is large enough so that you can see the details**. Students frequently come to me with a drawing that was done from a reference where the child's face was smaller than my pinky fingernail. And they are wondering why they can't get a likeness. If you can't see the details, you can't draw them! Draw from large photos.

You can enlarge photos quickly on a color copier or a computer printer. (If you want to solve the value equation, use the black and white setting .)

This photo would be easy to draw because the subject matter is uncomplicated.

This photo is too complicated for a beginner.

3. **Choose simple references at first**. When you switch to a new level of difficulty, you need to maximize the possibility of success. Choosing uncomplicated, simple subjects helps build early achievement and motivates you to practice. Practice in turn, makes you better.

Caution: Don't choose photos that need to be modified. That's too hard for a beginner. After you have mastered the ability to copy exactly what's in a photo, you can learn to modify what you see.

In my book and video collection titled, *Turning Family Photos into Art*, and, on the video titled, *Creating Dynamic Compositions, What do I do with the background?*, you will be given more information about formal composition. At this stage, however, you should not try to draw creative masterpieces. Just practice copying textures. Being creative requires some fairly advanced skills.

4. **Draw subjects you love**. If you love the subject you are drawing, even tedious detail won't seem tough. I can draw a tiger with lots of stripes and purr the whole time whereas that much detail in a tree would send me over the edge!

5. **Carry your camera everywhere**. You never can tell where you'll spot a great subject. One day, I was in the park when I came across a basset hound parade and saw this man and his pooch watching the craziness. I always cart my camera so I was able to capture the whole silly scene on film.

6. **Choose photos with a wide range of values**. Light and dark values define the underlying structure of an object. i.e. When there is a bone or muscle under fur, you'll see a shadow. Sometimes when you use flash on a white or black object, all the shadows will disappear and you won't be able to see the foundational structure or anatomy. If you use natural light, there is usually a full range of values, unless it's a black object in full sun like the photo of the cow below.

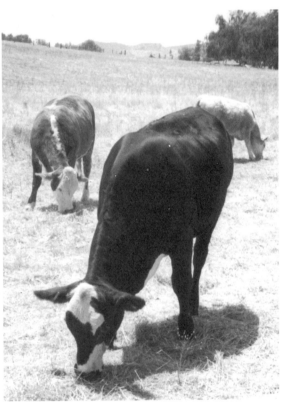

This photo captures the wide range of values in the cat, showing the contours which suggest the underlying anatomy.

Since this was taken in strong sunlight, most of the black cow is hidden in shadow. It would be very difficult to draw this because there is not a good range of values.

7. **Reference photography is different than artistic photography**. When you are shooting to create a fabulous photo, you must pay careful attention to the principles of composition. With reference photos, you are simply looking for detailed information. I always shoot my subjects from several different focal lengths: i.e. If I was photographing an animal, I shoot a close up of the eye, the nose, the ear, a shot of the head, a shot of the whole body, a shot of the body in the landscape, etc. Take all detail shots from the same angle.

Because I was simply taking references, I was not concerned that the llama in the background was cut off. I simply wanted a shot of the full body of the llama. I then pulled in for a close shot of just the head so I could see the detailed textures of the face.

The number one mistake that beginners make when working from a photo is this: Not using a full range of values. This cat was drawn by a beginner. I corrected it on the right side to demonstrate that more light, medium and dark values were needed. You can see that when there is a wider range of values, there is much more depth.

Although this is a good reference, it's hard to see Ashes' eyes, so Barbara shot a close-up of her cat.
See page 129. It's a good idea to take detail shots from the same angle, the same day, if possible.

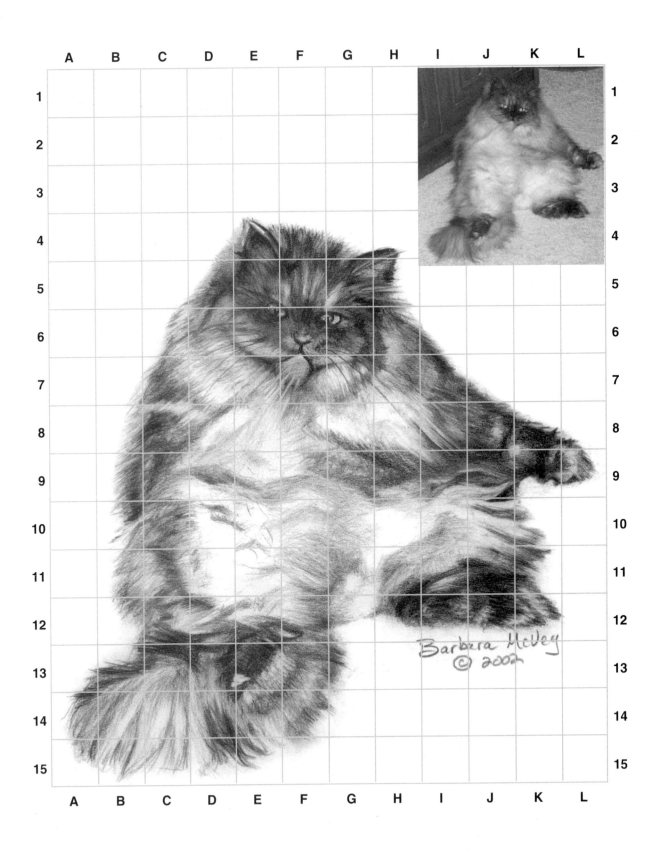

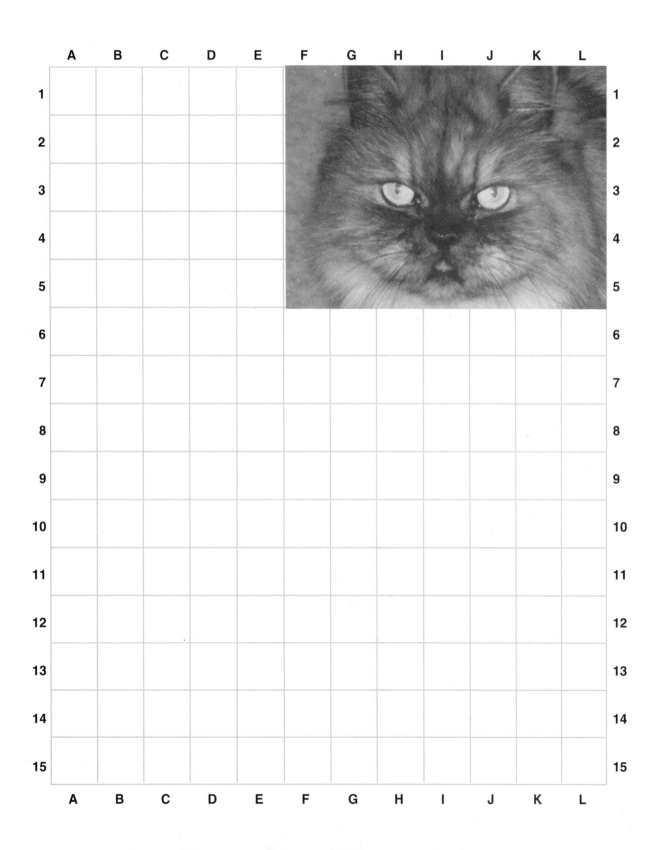

Draw this subject in the matching gridded box. If you prefer not to use a grid, draw the subject in your sketchbook. If you find it difficult to draw the background, just leave it out.

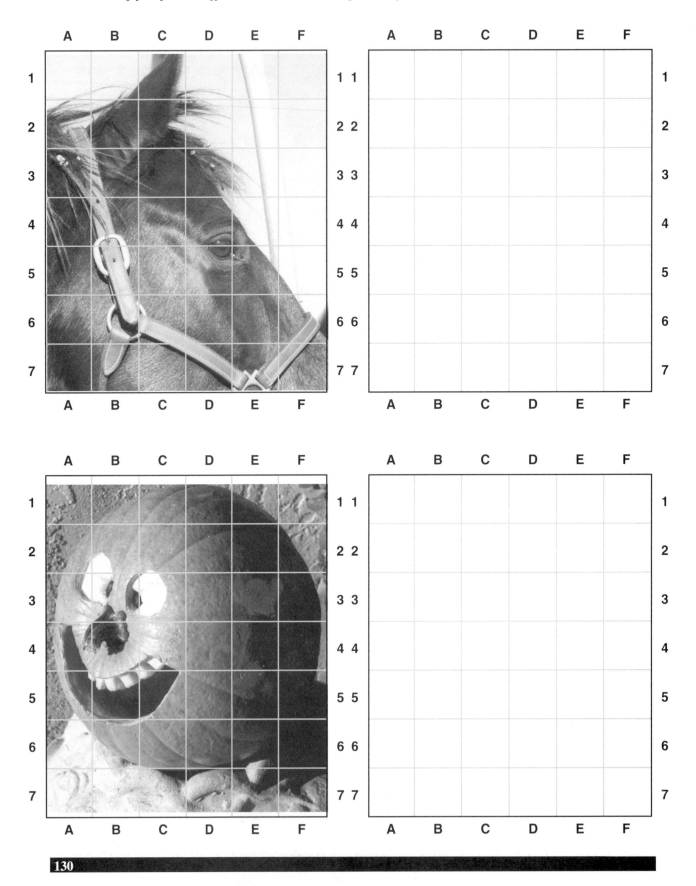

Draw this subject in the matching gridded box. If you prefer not to use a grid, draw the subject in your sketchbook. If you find it difficult to draw the background, just leave it out.

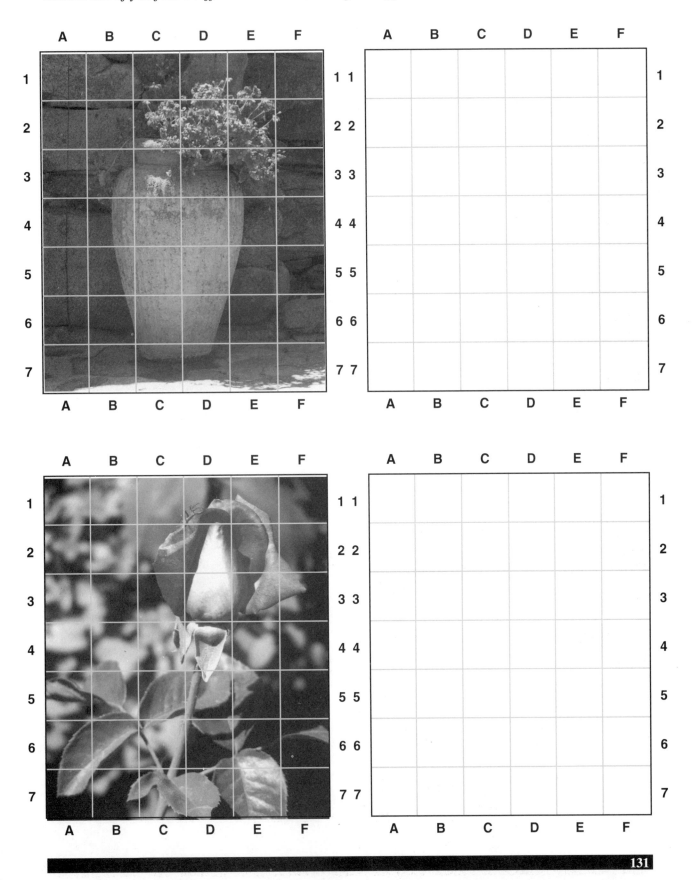

Draw this subject in the matching gridded box. If you prefer not to use a grid, draw the subject in your sketchbook. If you find it difficult to draw the background, just leave it out.

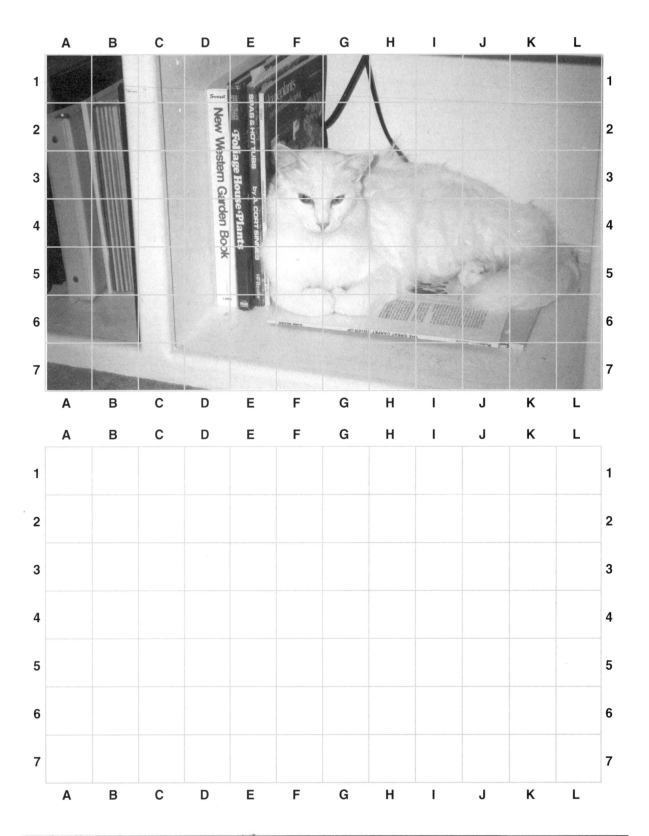

Draw this subject in the matching gridded box. If you prefer not to use a grid, draw the subject in your sketchbook. If you find it difficult to draw the background, just leave it out.

Draw this mountain lion in the matching gridded box. If you prefer not to use a grid, draw the subject in your sketchbook. If you find it difficult to draw the background, just leave it out.

Practice Page

Draw this pygmy falcon in the matching gridded box. If you prefer not to use a grid, draw the subject in your sketchbook. If you find it difficult to draw the background, just leave it out.

Draw this hibiscus in the matching gridded box. If you prefer not to use a grid, draw the subject in your sketchbook. If you find it difficult to draw the background, just leave it out.

Draw these lemurs in the matching gridded box. If you prefer not to use a grid, draw the subject in your sketchbook. If you find it difficult to draw the background, just leave it out.

Draw this owl in the matching gridded box. If you prefer not to use a grid, draw the subject in your sketchbook. If you find it difficult to draw the background, just leave it out.

Practice Page

You don't have to copy your photo exactly. Sometimes you can zoom in, leaving everything out except for the key subject. I call this "drawing only what you need to know."

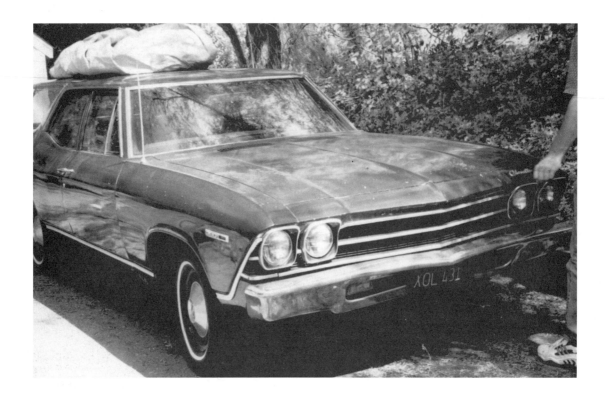

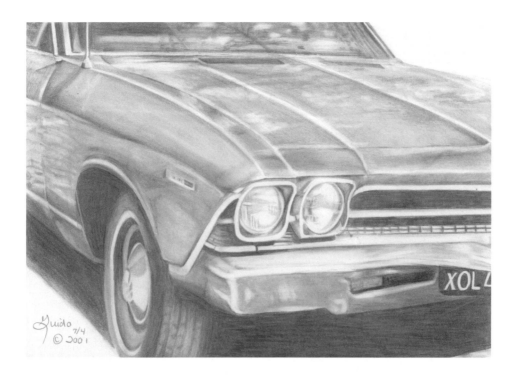

Draw this subject in the matching gridded box. If you prefer not to use a grid, draw the subject in your sketchbook.

What do I need? Sandra recommends...

Because I write books, videos, magazine columns and TV shows, I am always reviewing the latest products. I carefully test and update our brochure and website with the most recent high quality materials. I also make research trips to Europe to find new materials… (Aren't I noble? It is the least I can do for you as your personal toy shopper, eh?)

I do not list brand names on my order forms because products are frequently discontinued or updated. We simply carry the top of the line at all times. **CAUTION:** *If you use a lower grade than I'm recommending, you won't get the same results. You will think it is your skills, when it is actually your materials that are limiting you.*

To save you from floundering around in art stores trying to figure out what to buy, wasting money on the wrong products, I have grouped the best supplies in kits. All price levels are high quality, this listing just helps you select based on your budget! For your convenience, I've marked everything with these symbols, just like on our website:

Order videos and supplies from:
DiscoverArtWithSandra.com or call Discover Art toll free at 1(888) 327-9278
Price and availability subject to change. Prices as of 4/02.

If you are wondering where to start, here are Sandra's recommendations…

Videos listed in sequence … according to level of difficulty
The supplies used on each video are grouped beneath the description

LEVEL ONE

Beginning Drawing
Video Art Class and Workbook Set:

So You Thought You Couldn't Draw™
workbook *and* **4 companion videos:**

Drawing Basics, The Easy Way to Draw Animals, The Easy Way to Draw Landscapes, Flowers and Water, 7 common Drawing Mistakes and How to Correct Them. Watch me demonstrate shading techniques and draw along with me in your workbook.

REG. $224.00 **SALE: $119.95**

Drawing Supply Kit

ESSENTIAL

Sandra's Favorite™ English drawing pencils (12 degrees of wooded), Austrian Woodless pencil set- 6 degrees of hardness includes: (a pencil extender, an eraser, small sharpener, a water-soluble graphite pencil for landscapes and a pencil protector), a goat hair dust brush, and a battery powered sharpener.

DISCOUNT PRICE $59.95

LEVEL TWO

More Practice - Intermed.
Drawing Kit

BEYOND BASICS

The Art of Pencil Drawing book (Contains countless step-by-step subjects to draw.), wire-bound sketchpad with hard cover, grid kit, battery powered eraser, and eraser refills.

SAVE $6.80 $99.95

More Practice in Drawing Book Luxury Kit:

Indulge Me!

The Art of Pencil Drawing book (Contains countless step-by-step subjects to draw.), 9x12 sketch pad, grid kit, battery powered eraser, and eraser refills, plus the deluxe wooden box pencil set that contains graphite pencils, woodless graphite, water-soluble graphite, brush and drawing pencils. SAVE $10.00
$179.95

LEVEL THREE

Learn How to Mix Color: Color Theory

So many books make color mixing so complicated… it doesn't have to be! Watch this video and paint along with me. Although I teach this with acrylics ('cause it's much faster and cheaper), the theory you learn will apply to all art media. *You need to learn how to mix color before you try any color medium.*

Color Theory Video Art Class and Supply Kit:

ESSENTIAL

Video Art Class shown above, Color Theory Kit (with 7 acrylic paints), wire-bound watercolor tablet, palette paper, and a small round brush.

SAVE $22.00 Reg. $121.95 **SALE $99.95**

Color Theory Video Art Class and Luxury Supply Kit

Indulge Me!

Video Art Class above, Color Theory Kit, wire-bound watercolor tablet, palette paper, a small round brush, a collapsible sable brush and portable daylight lamp.

SAVE $16.00 Reg. 231.95 **SALE $215.95**

LEVEL FOUR

For eight years, I was the Executive Director of the International Colored Pencil Symposiums where we brought masters from around the world to share their colored pencil techniques. To save you hours of agonizing trial and error, I put these secret methods into the following books and companion videos. It's like bringing the workshops to your house… a private lesson with a master!

Getting Started with Colored Pencils
Video Art Class and Book Set

ESSENTIAL

Includes companion Award Winning 150 page step-by-step textbook - *Exploring Colored Pencil* and 4 Video workshops below:

1) Getting Started With Colored Pencils, 2) Special Effects With Colored Pencils, 3) Time Saving Colored Pencil Techniques, 4) Realistic Colored Pencil Textures, A Mixed Media Approach; with Sandra Angelo & David Dooley

SAVE: $66.00 Reg. $225.95 **SALE: $159.95**

Intermediate Colored Pencil Video
and Book Set:

Includes companion **Award Winning** textbook,
Exploring Colored Pencil and Videos 1-9 below:

BEYOND BASICS

Getting Started With Colored Pencils, Special Effects With Colored Pencils, Time Saving Colored Pencil Techniques, Realistic Colored Pencils Textures, and A Mixed Media Approach. Drawing Your Loved Ones: People, Drawing Your Loved Ones: Pets, Drawing with Colored Pencils on Wood, Building a Nature Sketchbook™. **SAVE: 44% and Receive NEW Video** - *Watercolor Pencils, the Portable Medium* **FREE** (when you purchase this set).

SAVE: $186.00 Reg. $475.95 **SALE: $289.95**

Colored Pencil Budget Supply Kit

ESSENTIAL

Starter set - 24 colored pencils, goat hair dust brush to control crumbs, Battery-operated sharpener, 100% white cotton tablet - 11x14.

DISCOUNT PRICE $69.99

Colored Pencil Better Supply Kit

BEYOND BASICS

Sandra's Favorite™ 48 colored pencil set (My favorite pencils, hard and soft leads, in colors I use most.), goat hair dust brush to control crumbs, Battery-operated sharpener, eraser refills, and two tablets: Black paper tablet (9 x 12), and Multicolored paper tablet (9 x 12).

DISCOUNT PRICE $169.99

Colored Pencil Supplies: Luxury Set

Indulge Me!

Sandra's Favorite™ 120 color pencil set These are the ULTIMATE in colored pencils! Unlike American pencils, the palette is traditional European artist pigments used for flesh tones, fur, landscapes, flowers, etc. Relatively hard leads...so your pencils don't wear out quickly. Keeps sharp point for detail, like fur, eyelashes, etc. Come in a three-tiered hand hewn cherry wooden box! Protects pencils, keeps them organized ... so portable.

For special effects, you'll receive these cool tools: Underpainting with Colorless Blender Markers, For burnishing & blending - Colorless Blender pencils, goat hair dust brush to control crumbs, Battery-operated eraser, eraser refills, Black paper tablet (9 x 12) and Multicolored paper tablet (9 x 12).

DISCOUNT PRICE $389.99

Award Winning Watercolor Pencil Video Art Class Set:

Includes 2 Videos:
Watercolor Pencils the Portable Medium, illustrates 6 techniques for working with watercolor pencils, as well as methods for combining them with water-soluble graphite, colored pencils, ink and watercolor.

Easy Pen and Ink Techniques for Artists and Crafters: Demonstrates how to use pen and ink with watercolor, watercolor pencils, on fabric, wood and more.

Reg. $100.00 **SALE: $77**

Watercolor Pencil Starter Kit:

24 Watercolor pencils with **FREE** brush and water container! **$29.95 Value!!** Goat hair dust brush, battery operated sharpener, watercolor hard-bound wire tablet, and Pocket Palette Watercolor Flower Book One.

DISCOUNT PRICE $89.95

Watercolor Pencil Better Supply Kit:

72 Watercolor pencils in a two-tier wooden box! Goat hair dust brush, battery operated sharpener, watercolor hard-bound wire tablet, Pocket Palette Watercolor Flower Book Two, and Parisian collapsible sable brush, size 1.

DISCOUNT PRICE $169.95

Watercolor Pencil Luxury Supply Kit:

Indulge Me!

72 Woodless Austrian Watercolor Pencils, Goat hair dust brush, battery operated sharpener, watercolor hard-bound wire tablet, Pocket Palette Watercolor Flower Book One, two Parisian collapsible sable brushes, size 1 & 6, and shoulder bag carrying case for pencils, brushes and sharpener.

DISCOUNT PRICE $299.95

Pen & Ink Supply Kit:

3 black pens nib sizes: 01, 03, 05; 6 colored ink pens in nib 05 – brown, purple, red, green, blue and black. Watercolor tablet for combining ink with watercolor pencils.

DISCOUNT PRICE $49.95

Drawing Animals Video Class and Book Set:

If you want to learn to draw animals, start with the video class, *The Easy Way to Draw Animals* and the **FREE** companion book, *Drawing Animals*, which demonstrates how to draw a variety of wild and domestic animals in graphite pencil.

After you master animals in black and white, take the video class, *Drawing Your Loved Ones, Pets* which shows key secrets for drawing eyes, noses, fur in colored pencil, & how to compose a drawing, etc.

Reg. $120.00 **SALE $99.95**

Drawing Animals - Blk/Wht Supply Kit:

ESSENTIAL

Goat hair dust brush to control crumbs, Battery-operated sharpener, 100% white bristol plate tablet - 11x14 , Wire-bound sketch pad 9x12, set of woodless pencils -(contains 6 degrees, eraser, pencil extender and pencil protector), and Grid kit.

DISCOUNT PRICE $79.95

Drawing Animals Supply Kit: Add Color!

BEYOND BASICS

Everything in Drawing Animals - Blk/wht supply kit, plus, Sandra's Favorite™ 48 colored pencil set (hard and soft leads, in colors I use most), plus a battery operated eraser and box of 70 refills. Sandra's Favorite™ 100% cotton plate Bristol tablet can be used for your preliminary graphite drawing which you can then photocopy onto a sheet of colored paper in Sandra's Favorite™ Portrait Paper Tablet.

DISCOUNT PRICE $239.95

Drawing Animals Luxury Supply Kit:

Indulge Me!

Includes all of the above except instead of the set of 48, you get Sandra's Favorite™ 120 color pencil set. These are the ULTIMATE! Hard leads...so pencils don't wear out quickly. Traditional European palette. Keeps sharp point for detail, like fur, whiskers, etc. In three-tiered hand hewn cherry wooden box! Protects pencils, keeps them organized ... so portable.

DISCOUNT PRICE $429.95

Coming soon… new book called Turning Family Photos into Art… Step-by-Step Lessons for the Absolute Beginner!

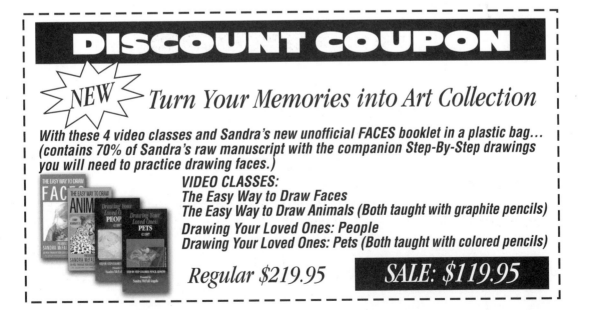